Praise for *The Siege of Sarajevo*

"In a world facing the worst refugee crisis in history, this is an important and timely book, a compelling reminder of the heartrending dilemma of escaping terrible violence and leaving loved ones behind. Remarkably, the book is written entirely by Bosnian refugees and their families, and captures the Sarajevo experience better than anything else I've ever seen."

—John Zaritsky, Oscar-winning filmmaker

"A powerful, well-written account of a loving family torn apart by one of the longest sieges in modern history. Compelling and heartbreaking story but ultimately a testament to human spirit, kindness and resilience."

—Atka Reid, author of *Goodbye Sarajevo*

"By reading personal letters sent from Sarajevo during the siege, you become part of the story, too. … The raw account and description of the events is striking, explosive, and often reads as a movie screenplay, forcing you to turn page after page, letter after letter—as you become Sarajevan yourself."

—Zoran Stevanovic, UNHCR, Central Europe

"A gripping, vivid, and vital reflection on a too often forgotten bit of very recent history. … Sanja's story is at once sickening and beautiful, horrifying yet hopeful. In times such as these, we need stories like this."

—Paige Martini, editor

"This book is a brave effort to uncover the dark history of Sarajevo and unravel memories often best kept buried. Its strength lies in bringing two stories, occurring worlds apart, together. … *The Siege of Sarajevo* shows, with each page, that some of the best war stories are written by refugees."

—Ahmed Buric, author

To David: [signature] Sanja Kulenovi Sept 2019

THE
SIEGE OF
SARAJEVO

One Family's Story
of Separation, Struggle,
and Strength

• • • • •

SANJA KULENOVIC

KiCam
PROJECTS

Published by KiCam Projects
109 N. Main Street,
Georgetown, OH 45121

KiCamProjects.com

ISBN (paperback): 978-1-7335462-0-1
ISBN (e-book): 978-1-7335462-1-8

LIBRARY OF CONGRESS CATALOGING-IN-PUBLICATION DATA
Names: Kulenovic, Sanja, author.
Title: The Siege of Sarajevo : one family's story of separation, struggle,
and strength / Sanja Kulenovic.
Description: Georgetown, OH : KiCam Projects, [2019].
Identifiers: LCCN 2019011005 (print) | LCCN 2019020585 (ebook) | ISBN
9781733546218 (ebook) | ISBN 9781733546201
Subjects: LCSH: Kulenovic, Sanja--Family. | Bosnian Americans--Biography. |
Sarajevo (Bosnia and Herzegovina)--History--Siege, 1992-1996--Personal
narratives, Bosnian. | Kulenovic family. |
Refugees--California--Pasadena--Biography. | Refugees--Bosnia and
Herzegovina--Sarajevo--Biography. |
Immigrants--California--Pasadena--Biography. | Sarajevo (Bosnia and
Herzegovina)--Social conditions--20th century. | Sarajevo (Bosnia and
Herzegovina)--Biography.
Classification: LCC E184.B675 (ebook) | LCC E184.B675 K85 2019 (print) | DDC
949.742--dc23
LC record available at https://lccn.loc.gov/2019011005

Cover design by Mark Sullivan
Printed in the United States of America

To my daughters,
Nadia and Leila

In loving memory of Margaret Lambert and Ruth Hughes

"Today, I am a citizen of the world. It seems a long time ago that I was a citizen of a proud, beautiful city, known as a symbol of peace, a 'little Jerusalem of Europe.' It was a place where East and West met, where churches, mosques, and synagogues stood side by side for centuries, and where people lived in harmony for generations. "Yes, I come from Sarajevo."

Opening of my speech given at a United Nations fundraising event sponsored by the then-President of the General Assembly of the United Nations, Mr. Stoyan Ganev, to benefit Bosnian women and children during the war.
Held in Beverly Hills, California, July 1993.

Introduction

Sarajevo was founded in 1462, during Ottoman rule in the Balkans. Its first residents were Slavs who had converted to Islam, Catholics, and Orthodox Christians. Although not equal, all faiths were recognized by the Ottoman authorities. Alongside many mosques, the first Catholic and Orthodox churches were built in the early sixteenth century. After being expelled from Spain in 1492, Sephardic Jews arrived in Sarajevo in the 1550s and built their own quarter and a small synagogue. Under the leadership of Sarajevo's greatest benefactor, Bosnian governor Gazi Husref-bey (1521-1541), the city prospered and became a major political and trade center of the Empire, second only to Istanbul.

Consistent with Ottoman custom, residential areas were structured around houses of worship and other religious institutions and, given the size of the city, were built very close to one another. The city center, the *carsija* (pronounced char-shi-ya), was where official and trade activities took place. It was also the birthplace of Sarajevo's cosmopolitanism, where people of different social statuses and religions interacted, acknowledging and respecting one another's distinctive backgrounds. The *carsija* is where people learned to live together, eventually adapting this lifestyle to such an extent that, in all their diversities, they represented one identity—that of a Sarajevan. This philosophy of common life, the sense of belonging to a community as a whole, beyond belonging to an ethnic or a religious group, was carried through generations and became an unwritten law that Sarajevans did not abandon even under the most challenging of circumstances. As governments changed and city demographics shifted drastically, the institution of *carsija* lived—through invasions, fires, plagues, and wars—engraved on the heart of every Sarajevan.

Four centuries of Ottoman rule ended in 1878, when Austro-Hungarian troops invaded and occupied Bosnia. With the Habsburg Empire came new, Viennese influence; though it lasted only forty years, Sarajevo was transformed into a sophisticated city at the cultural crossroads between traditional Istanbul and modern Vienna, rare in early-twentieth-century Europe. The Catholic cathedral, Evangelical church, and Ashkenazi synagogue were built in new, Neo-Gothic, and Pseudo-Moorish styles, adding to the cluster of existing old

mosques, bazaars, and craft shops in the *carsija*. The population grew to over 50,000, now composed of nearly the same percentage of Muslims and Catholics, followed by Serbian Orthodox, Sephardic Jews, other Jews, and Evangelicals.

The twentieth century, undoubtedly the most turbulent era in the city's history, was marked by several changes of regime and the devastation of three brutal wars. In June 1914, Austrian Archduke Franz Ferdinand and his wife, Sophie, were assassinated on the streets of Sarajevo, prompting a sequence of events that led to World War I and the collapse of the Habsburg monarchy four years later. In the years between the two World Wars, Sarajevo was part of the newly formed Kingdom of the Serbs, Croats, and Slovenes, but given its diversity, it was not attractive to the new government, which favored cities such as Belgrade, Zagreb, and Ljubljana, with national majorities. Sarajevo suffered economically and culturally, but this decline was modest compared to the crisis when German occupiers marched through the *carsija* with swastika flags in April 1941. In the next four years, more than 10,000 Sarajevans lost their lives. Many fell defending their city, as national heroes, partisans, and members of the opposition and resistance movement.

In April 1945, Sarajevo was liberated and became the capital of Bosnia, one of six equal republics of the Socialist Federative Republic of Yugoslavia, and the only one with no absolute population majority. During the next four decades of socialist rule, led by Josip Broz Tito and the Communist Party, Sarajevo experienced extraordinary growth. Thanks to the first post-war youth brigades and ecstatic rebuilding efforts under the Brotherhood and Unity slogan, which included rapid industrial development and the formation of the university, national library, opera, and the Academy of Arts and Sciences, Sarajevo became a well-known European city, reaching the pinnacle of its growth in 1984, when it hosted the Winter Olympic Games. With half a million residents, very diverse in backgrounds but at the same time noticeably similar in their nature and behavior, its rich and varied architectural styles, the image of its *carsija,* and the hospitality of its people, Sarajevo attracted visitors from all over the world and became a metaphor for tolerance, harmony, and common daily life.

This extraordinary and incomparable city is my hometown. I am a Sarajevan. I am also a Russian-born Bosnian. My father was a diplomat who served in the Yugoslav embassy in Moscow and later as a minister in the Federal and Republic government of Yugoslavia and Bosnia. My mother was an architect whose career started in academia but later focused on architectural design and

urbanism in Sarajevo. My parents were Muslims by nationality but did not practice Islam. My grandparents, however, were religious and observed Islamic holidays. When we were small, in exchange for gifts on Eid, my brother and I would recite a few prayers our grandmothers had taught us. But these "songs," as we called them, were not any different from "songs" our nanny, a devout Catholic, read or sang to us, except that they were in Arabic and others in Serbo-Croatian.

As I grew and my family extended into other nationalities, I never formed a clear opinion about my own religious preference. My heritage made me a Muslim, but Islam was my religion as much as any other, if at all. Out of respect, I never admitted to my grandparents that I ate pork, even during Ramadan, went to midnight Mass at Christmas (because it was a popular thing to do), and that my first job was to accompany the Methodist church children's chorus on piano at Sunday services. To me, the muezzin's *ezan*[1] from a mosque minaret evoked the same peaceful feeling as the sound of church bells, and I loved hearing them overlapping in the old *carsija* at sunset. I was, and I loved being, a little bit of everything Sarajevo encapsulated.

My friends were brought up in families similar to mine, where we perceived people as good or bad based on values other than ethnicity or religion. Some of my friends were Serbs, some Croats, some Muslim—but many more were children from mixed marriages—and in most cases, I did not know their origins, except that most had been Sarajevans for several generations. We all grew up together. We went to the same schools, knew one another's cousins, were proud "Tito's Pioneers," and played on the same sports teams. We talked in the same jargon and with the same accent, loved the same songs and movies, and laughed at jokes only Sarajevans could understand. We had the same favorite foods. What set us apart was which of the two local rival soccer teams we rooted for or which restaurant made the best *cevapi*[2] in town.

In 1983, when I was seventeen, I was selected for the American Field Service high school student exchange program. It was a privilege and an opportunity not to be missed, but at the time, I secretly wished I would not be chosen. Even though I loved to travel and did so whenever I could, a year away from my family, my friends, and my Sarajevo seemed overwhelming. I had never dreamed about going far from home for so long—after all, except for my early childhood years in Moscow, I lived in Sarajevo and expected to do so for the rest of my life. Like my mother, I had thought I would one day live five minutes from my childhood home, with all my relatives within a few miles' radius. I enjoyed life as

it was and looked ahead to an exciting senior year in Sarajevo. With the Winter Olympics coming, the city looked beautiful, and my friends were going to participate in ceremonies or have fun jobs during the Games.

I did not realize then what a defining moment of my life happened there, in my high school classroom in Sarajevo, when my name was called—not until years later, when I arrived on my honeymoon with my husband, Djeno, at the very same house on Rose Villa Street in Pasadena where I had lived that school year.

Chance decided my fate and the path my life took, and most often I was faced with a fait accompli, and fell into one of the possible currents; only a different chance could cast me into another.

You could neither avoid it nor refuse it. It was yours, like the water you fell into. And you'd either sink or swim.

From *The Fortress*
by Mesa Selimovic

PART I

1992

1

The siege of Sarajevo started on April 5, 1992. Not long before that, in some distant and unreal life, we were tourists in California enjoying our honeymoon on the Malibu beaches, thinking the world was a perfect place and that things could not be any better. Then, with the morning's first cup of coffee in hand, we turned on the TV. The face of the earth blackened in a second and our lives, as we had always known them, ceased to exist.

"Sarajevo, the capital of Bosnia, was pounded with thousands of bombs from positions situated in the hills above the city," CNN morning news reported, interrupted by the sound of bomb detonations and footage of burning buildings and black smoke in the background. "Local authorities report that ten civilians were killed in the attack, and at least twice as many were injured and transported to the city's main hospital…"

First I felt confusion, then in a furious crescendo came disbelief, rage, worry, and fear—as if all of the orchestras in the world were united in announcing the huge and powerful Theme of Fate knocking on my door and entering my life, molto ritardando, like an omen. Three short notes and a long, deeper one, each of them as strong, loud, and frightening as the detonations I heard pounding in my ears. Even though my heart was hoping this was all a terrible mistake, the reality of the news was so harsh that it struck me like a bullet. I could barely comprehend all my feelings. They crashed onto me like an avalanche and I was losing solid ground by the second. *Why? What have we done? What have my parents done—retired people, who worked their whole life loving that city and country? What is happening in Sarajevo?*

In the following weeks, I learned what it means to physically hurt from worrying. I began to understand that "hopeless" is not an abstract term. The news was beyond comprehension: familiar picturesque sights smoldering; reporters' voices competing with exploding shells; tanks full of sinister, heavily armed men roaming the streets; high-rise apartment buildings ablaze, with people hanging from windows and balconies, frantically trying to escape. Thousands of shells slammed into homes, centuries-old buildings, museums, schools, and parks. The maternity ward of the hospital was hit. There were seventy women

and 173 babies inside. They even shelled people gathered at funerals for three newborns who were killed.

For Djeno and me, watching all of this from 7,000 miles away, it was a time when we had to use all our mental strength and self-discipline to battle the surge of emotions and frustration, to calm down enough to try to learn the facts. We were in a state of shock. Even after a couple of weeks, we could not fully grasp what was going on. We could see on the faces of Sarajevans on TV that they did not understand either. They ran through the streets in panic, faces contorted with fear, bodies bent, and heads hunched. All of their reactions were so fast, almost uncontrollable, and their yelling and screaming so loud, so spine-chilling, that later I would see and hear it in my sleep. Hours after watching the news, Djeno and I would still be walking around the room in circles, sweating and fuming, kicking things from rage and hopelessness, swearing as loudly as we could. At other times, we were so exhausted, all we could do was sit in one spot and cry our hearts out.

The world watched as our beloved city was destroyed, day after day. The world was counting the dead and wounded:

"Over the past twenty-four hours, forty-three people were killed and seventy-nine wounded. Terrible."

"Seven killed, fifteen wounded: a relatively quiet day in Sarajevo."

This was no ordinary war. And why should they speak of it as a war anyway? This was an attack on civilians, not a war between armies. These victims were not against anything or anybody. Their only wrongdoing was to be living in Sarajevo in spring of 1992. Was that such a horrible mistake? Why wasn't anything being done to stop the madness? What if it had happened to Paris or London? Would anyone have stepped in to save a fancy city in Europe and its people? Of course. The world would not have allowed the Eiffel Tower or Tower Bridge to go down. But why was Sarajevo any different? Did people elsewhere not realize that this could happen to them, too? Could they not understand that one day they could be going to work, kissing their kids before school, and enjoying afternoon coffee at a street cafe, and the next day they could be running into shelters for their lives? There might not have been the Louvre or Buckingham Palace here, there might not have been any queens or kings around, but there were people. There were my parents, my only brother, my in-laws, and my friends. Six hundred thousand citizens of Sarajevo were surrounded, trapped in the valley 7,000 feet below heavily wooded mountains packed with heavy artillery. There was

indiscriminate killing in the heart of old, "civilized" Europe, a few hours' driving distance from Vienna, Budapest, and Rome. I asked again, *Why*? The question stayed with me like deep, heavy music, changing a little bit but always there—raw and unharmonized—incorporated into every variation of life, every day and night of the year.

It was May 27, 1992.

"Please be advised that the following program contains graphic material and scenes rarely seen on television," the news anchor warned. "This footage was filmed in the center of Sarajevo, after two mortar shells, an 82mm and a 120mm, slammed into a group of people in line for bread outside a downtown bakery. Twenty-two of them were killed, and more than 160 wounded."

My heart started pounding like a drum. I remember thinking, *Please, God, do not let me see my mom or dad or anybody I know...* The bakery was in my parents' neighborhood, about five minutes' walk from their house, on one of the prettiest streets in downtown's pedestrian area. It was always full of people strolling and was lined with cafes, shops, and restaurants, vibrant and lively.

I heard frantic screams, then saw a pile of dead bodies mingled with the injured, lying in pools of blood, moaning. Heads, limbs, and other body parts were scattered all over, yards away. Human flesh stuck to the walls of the surrounding buildings. Blood flowed slowly down the street.

Djeno and I were turned into frozen statues. We stared at the images in silence, sickened. Suddenly, Djeno jumped up:

"Oh, my God! Is that Professor Djikic? Remember him? That is him, Sanja, look!"

Yes, it was Mr. Djikic, one of Djeno's college professors, father of two sons, a charismatic and funny fellow. The last time Djeno had seen him was when he stood in front of a whiteboard explaining the principles of mechanics. He was now lying in his own blood, his lower body completely saturated. He was screaming in sheer panic, trying to crawl, extending his blood-covered arms toward the cameras. He had just lost both of his legs.

Guilty of waiting in line for bread.

The next day, something extraordinary happened outside the bakery. Bloodstains strewn with flowers were still fresh on the asphalt when a man in a tuxedo emerged from one of the shattered buildings. He slowly walked

toward the bomb site. He was Vedran Smailovic, principal cellist of the Sarajevo Philharmonic Orchestra. He brought his cello and a small stool, which he placed in the crater. He quietly positioned himself and began to play. The sound of "Adagio" filled the air. It flowed through the devastated streets of Sarajevo, above the screams, bombs, and bullets that still echoed in everyone's minds, transporting the city to a time and place where nothing existed but harmony and peace. People stopped running and listened, not thinking about the snipers still aiming at them. Others brought flowers to his feet. Foreign reporters in bulletproof vests took pictures. And he played the "Adagio" twenty-two consecutive days—once for each person killed.[3]

The media called it "The Breadline Massacre." Overnight, all TV and radio news stations became interested in the Balkan city of Sarajevo. The picture of Professor Djikic appeared on the front of major newspapers and magazines. The United Nations met. Officials began their endless speeches and empty promises. In the real world, away from the façade of politicians' suits and the media's hunger for sensations, life became steadily worse for the people of Sarajevo. They lost water and power. Railway and bus stations were shelled and burned to the ground. The only airport in the city was shut down to all traffic. Our letters were returned with a stamp: "Due to war, impossible to deliver. Please return to sender."

And then, as if this were not enough, what we had feared most happened. One night, after hours of dialing, we discovered the international phone lines to Bosnia were dead. People in the city were cut off from the rest of the world. We lost communication with our families for months to come. Sarajevo was under total siege.

From then on, we had no way of knowing if our relatives were alive or dead. Every morning we read the papers praying we would not recognize any names. Every evening we watched the news fearful we might again see somebody we knew. Even when we did not, there was no relief. At the rate of one bomb per several minutes, coupled with the persistence of countless snipers, how could we sleep knowing that any second, our parents, relatives, or friends could be gone— even sitting in their own homes? We now understood there was no place to hide in Sarajevo. Your bedroom could be your death chamber. Your backyard could be your last resting place.

Often, I would wake in the middle of the night, sweating, thinking maybe Mom and Dad had been dead for weeks and I did not know. *Where were*

they buried; who was there? What if they were badly wounded and had become invalids? Who had helped them? What had happened to my brother, Zoran? Was he alive any longer? Did I have anybody?

I relived each day's events from the news in my dreams, with my family and friends in them. I noticed I was using the word "God" more than ever before.

When I look back at that time, it seems like a big blur in my mind, a mass of feelings and emotions, tumbling over one another. This was the only time in my life when I did not know the exact dates of events and could not put them in order. Days and nights in turmoil, mingling with each other, all fought for a place in my memory, but nothing stood out. Nothing except the same ominous theme in the background of my mind, the same old forte phrase ripping through my ears, warning of more to come. I felt lost in translation, floating somewhere between Bosnia and America, waiting for something significant to happen and not really belonging anywhere. My heart was in Sarajevo, but my realistic mind was here. These two worlds never seemed to touch each other, and for me, it was impossible to think of America as home. Yet, it was the only home I had.

The first letter came from London, carried out from Sarajevo by a British journalist. On the other side of the envelope, only three words were written: *Chile, Sarajevo, 1992.* I stared at it in disbelief for a few seconds, then ripped the envelope apart, hands shaking. Chile was one of Djenö's best friends. He had been a journalist for a popular radio station before the war. He and Selma, his wife, had returned from a trip to the United States just before the siege began. They flew into Sarajevo on the last plane to land in the city.

Chile's letter read:

Situation in Sarajevo is unbelievable. You need to thank God every single day that you are not here. Think of the worst possible scenario, and then double it, at least. It's total madness to live in an atmosphere where you are in constant fear for your life.

I am working for VIS NEWS/WTN pool. We have been shot at more than a dozen times already. I am lucky to still be in one piece. You don't hear a bomb that's coming directly toward you. Screw them. I have seen so much—if I make it alive, I'll be haunted by these images for years. I know it. But, this isn't a movie, man, it is REAL HORROR.

Remember Loza? He got killed doing the same job I do. Jordi, a Spanish photographer, was killed—a day before, he and I drank together. I have seen people cut in half in front of my eyes; I have heard news of many friends gone forever. I think of them for a moment, but there is no time for grief. The battle for survival keeps you going. This is one horrible nightmare that lasts twenty-four hours a day.

I am not afraid of instant death. It comes and you are gone. But I am scared of, God forbid, becoming an invalid or something like that. I don't know why I am even trying to explain all this here, 'cause you are not gonna get it anyway... Maybe one day, I can tell you all the stories. You'll probably have questions I won't have answers to, but the good thing is that you will NEVER know what it was like to be in Sarajevo in 1992. Thank God for that. Seriously, thank God.

I've cried two times since the war began—once when Loza was killed and second while reading Sanela's letter. Only then, I realized the depth of her simple words: "I have never in my life known how much my friends mean to me and how

much I miss you guys." Sanela is now in Croatia, after a horrendous escape (one day you will hear the story). Krilla is still here—he joined the defenders' forces, special unit. He is fighting at the first front lines and is somehow convinced that bullets can't do anything to him. He has already been wounded and has a piece of shrapnel in his elbow. Thank God, it was not serious.

Every night when I go to bed, I hope to dream of the four of us sitting together, laughing. Oh well, what happens, happens. It's all fate.

All our folks are still alive. Houses are not badly damaged; some, but not to worry. Except for Selma's parents' house—only the walls remain. They've lost everything and moved several times from place to place…But, no lives lost so far.

The only thing I can hang onto is the memories from the past—everything else is somehow taken away. Man, we have to get together again to play a round of cards. We just have to, or else my life will never have meaning again.

I dream of sending Selma to some other country, anywhere…don't really care.

Gotta go back to my world of horror now. Hopefully, the sun will shine in this city again someday.

Sorry for a confused letter. Trust me when I say that I have never wanted to see anybody more than I want to see you guys now.

Selma added:

I remember you guys asking me if I could ever live in America. I remember my answer, too. Now I can tell you that I would rather live at the end of the world than here. Sarajevo will never be the same, even if this ends tomorrow. We were lucky to have lived here before, because people who didn't will never know how beautiful life in this city was. Those days are gone forever. Take care, keep your fingers crossed for us, and we hope that we will see you one day again. If not, just know that you have been the best of friends.

Then came the call.

"Djeno? It's Chile."

"Chile? You? Man, where are you? How are you? Are you all alive there?" Djeno yelled into the receiver and started walking fast around the room.

"Listen, I can't talk much on this phone. This is a satellite phone…Yes, yes, everybody is still alive and okay. Listen, Amila and the kids are out, just wanted to tell you that. They should be in Croatia by now. Try calling her on this

number; not sure that it'll work though. Ask these people to call her; she is registered as a refugee. I've got to go now; I'll call you again if I have a chance."

He hung up as soon as Djeno wrote down the number.

Djeno was holding the phone in his hand, still trying to make sense of the words he had heard. His sister Amila and her two boys, seven-year-old Adi and three-year-old Dino, were apparently out of Sarajevo. Where was her husband, Jasko? Refugees? Where? Djeno dialed the number with trembling hands.

Everything Chile said was true.

About two weeks after the call came a letter from Amila:

Dear Sanja and Djeno,

I am writing to you from Split, Croatia, where we arrived three days ago and are now officially called "Bosnian refugees." God, how hard it is even to say it. I can't stop crying... Trust me when I say I didn't want to leave Sarajevo and that I am here against my will. But, Mom, Dad, and Jasko all convinced me that it would be wise, to say the least, to leave while I still could. Because of the kids, of course. I am not sure how much, if anything, you know about the Children's Embassy in Sarajevo. To tell you briefly, it's an organization that tries to get as many women and small children out of the city as possible. The first couple of attempts to get us out failed for different reasons. Just when I thought that it was no longer possible (because they had about 1,500 children on their waiting list, plus they ran out of vehicles and out of gas), Jasko and three other men from our building found an abandoned, bullet-riddled van that looked as if it came straight from an Alan Ford cartoon. It didn't even have windows, just newspapers and some plastic instead. It had no gas. Jasko and the others somehow pulled out all the gas they had in their cars (can't use them anyway), and Adi, Dino, and I, along with three other women from our building and their six children, were put on a convoy to take us out. I was allowed to take only one bag of clothes for Adi and Dino and my purse with our documents. Now, you know that Split is only about a six-hour drive from Sarajevo—well, it took us two days and two nights to get there. We took side roads, even some dirt roads I didn't know existed. We stopped in little villages along the way. I don't even know their names.

During this trip, and especially when leaving Sarajevo, my eyes have opened up to what the situation really is—nothing and nobody can enter or exit the city without going through criminals' check points and controls. I don't even know how the people from the embassy got us through. Not too many convoys have made

it. Sarajevo is a huge prison. They want to destroy it, intentionally, systematically. They are shelling all parts of the city, especially residential areas. Hundreds and hundreds of bombs fall on people's homes every single day. I don't think there is a single piece of glass remaining on the windows in Titova Street.[4] It's beyond belief. Snipers are another story. You have no idea how dangerous they are. You cannot hide from them. They are everywhere around the city, aiming at people who try to cross intersections to get water, or food, or whatever. Tell me, how is this called a "civil" war? Because one side is civilians, with no guns, no power, no intentions to kill anybody—is that what makes it "civil"? I am sorry I am just pouring out my frustrations to you, but first, I don't have anybody else to talk to, and second, it's better to write than to scream.

When we first got here, they put us all into the gymnasium at a local school. I couldn't think of sleeping there. There were hundreds of women and kids in a huge hall. When I saw worms crawling out of Dino's mattress, I took the kids out and decided to stay in the van. Luckily, the weather was nice.

Split is overcrowded with Bosnian refugees. It's hard to find housing. Our group of twelve (four women with eight kids) was extremely lucky. We met a man who had a house in Solin, which he was planning to rent out. I guess he just felt too sorry for us and he is letting us use the house for free until we can find something more permanent. We still think we will not need anything, as we hope to go back to Sarajevo as soon as all this ends, and that can't be very long.

Solin is about ten miles from Split, and as refugees, we have free public transportation and are also entitled to some help from the local church group (in terms of food).

Believe me that I don't even know what is happening to me. A few months ago, I was going to work every morning defending my clients, the kids were in day-care, we went on a ski trip, bought a new painting, planned our next trip... What happened to me? Was that a dream or is this a dream? I have no idea how long we will stay here. I hope not more than about ten days or so... but, how will we go back? What is life going to be like? Will I still have a job?

Please write to me. In case you have an opportunity to call, you can call the neighbors here. I will give you their number, and they can call me to come and talk to you. They are nice people, and they want to help us. They will take messages for us from our husbands and families in Sarajevo, if we get any. We'll try to send notes through the Red Cross.

I just want to go home soon. I can't think of anything else right now.

We read the letter over and over for days. It was in some strange way a turning point, a harsh reality check. Proof of a new life emerging in front of us. One we had to face with our minds cleared from the past, as though it never existed. We were no longer a honeymooning couple. Period. We were two people stranded in a foreign country. Fact of life. The war was raging in our homeland.

As I tossed and turned these thoughts in my mind, I slowly began accepting them as truths. I gathered my scattered, disturbed emotions like little pieces of broken glass and glued them together into a compact mosaic—a mind-set of logic and reason. Part of me that had been stubbornly clinging to the past, shouting from deep inside that nothing had changed, was now silent.

At times, I felt utterly powerless and desperate, but I fought hard to dismiss these feelings quickly, before they had a chance to get the better of me and drag my soul into misery. I told myself that if the people of Sarajevo had enough strength to go through this, I must have it, too. I should not complain—instead, I should consider myself extremely lucky. If Amila could cope as a refugee with two small children, was there any reason why I should not be able to cope with my life here? Despite everything, it was still my life and I had to *live* it.

Djeno and I knew we had nowhere to go. Our visas were expiring and our old Yugoslav passports were no longer valid. We became two stateless people with some money in our wallet and two suitcases of clothes. We had to start over from zero. Actually, as one of our friends said, not from zero—we had to climb a mountain to get to zero. There was nothing but hurdles and obstacles ahead of us, nothing but questions for which we did not have answers. *How would we get work permits when we had tourist visas in worthless passports? What would we do to earn money to support ourselves? What would happen if we became ill? If we became illegal immigrants? Would they extradite us? To which country? Where in the world could we go if we could not stay here? Which governments now recognized Bosnia as a country?*

Each new question was more complex and more difficult to solve—like notes forming into complicated chords, sounding real, precise, and relevant, shaping into the music of our life and our destiny. We did not know how to cope with it all. Not even the smallest piece of it, the simplest chord.

We had to start figuring things out and start making plans.

"What are we going to do about money?" I asked Djeno, knowing how careful we needed to be with it. "We should make a budget or something. We don't have a lot."

I almost cried. I was not used to conversations like this.

"But we do have some," Djeno tried to encourage me, as he always had before. "Don't be so negative please."

True, he was coping with all of this much better than I was. He had always been the more optimistic one of the two of us.

"Think about this," he said. "We are lucky to be here. We are young and healthy. We have each other. Isn't that already a good start? Something will eventually come up for us. We'll somehow get through this together. Don't make it worse than it really is."

I knew he had no idea what that "something" or "somehow" might be, because our situation, as I saw it, was quite desperate. But I wanted to believe

him. He was the only bright light in my life, and I was so grateful we had each other.

We sat down and counted our assets: exactly $2,860. We put $1,000 in an envelope and sealed it. That was going to be opened in case of extreme emergency. The rest we would spread over six months. We figured that, in six months, the "something" Djeno was referring to would have to happen or we would go home. This war could not last for more than that.

Three hundred and ten dollars a month should be enough, I thought, considering we did not have to pay rent. We were lucky to have a roof over our head for now. Margaret, our longtime family friend and host, told us we could stay with her for the time being. We would only need to pay our phone bill. She would take care of other utilities. This was huge. We knew we were not going to be homeless. We also knew we could easily feed ourselves on about $50 per week. That would maybe leave us with a few extra dollars to cover unexpected costs.

I felt a little better. I started writing down all our expenditures, down to fifty-cent doughnuts, twenty-five-cent newspapers, and ten-cent copy services. It made me feel good that I was in control of something at least.

Several weeks dragged by. Still no phone calls, no letters, no news from our relatives at all. Our only hope to get through to Sarajevo was to contact ham-radio operators in neighboring Croatia. It was a complicated system, but history has shown that, in times like this, people's imagination proves indispensable.

We had known about the ham-radio guys for some time, but after many days and nights of dialing in vain, we began to question the process altogether. First, the operators in Croatia had to establish a connection with operators in Sarajevo—in itself a huge challenge. These people, like the rest of Sarajevans, were hiding in basements and shelters most of the time. The next hurdle was to find a local operable phone. The main post office in Sarajevo had burned down, most local communication channels were destroyed, and only a few phones per neighborhood worked. If this were not enough, the connection had to last long enough so people who did not have phones could actually get to a particular phone. On top of all this, radio operators in Croatia were so overwhelmed with phone calls from abroad that they had to establish a priority system. Each caller had a number, and only certain numbers could be called on certain days. Also, in the interest of fairness, they allowed only a minute or two per conversation.

One night, the impossible happened. After we listened to the busy signal for hours, the phone in Croatia finally rang. I said my number, and they asked for a number in Sarajevo. I could hear them trying to establish a connection with operators in Sarajevo. A long minute or so of beeping and buzzing passed. "Pick it up, pick it up, please…" I whispered to myself. When they did, I was so shocked that I could not tell if I had actually heard it or if I had imagined it. I wanted to ask for reassurance but knew this was too precious a moment and I did not want to lose it. Another eternal minute passed. Then, I heard a voice:

"You have a call from Sanja from Los Angeles. Please say your sentence. You have one minute for this call."

And then, as if from some other planet, mixed with so many different noises, I vaguely heard my dad's voice:

"We are alive, we are alive. Everyone in the family is fine. Sanja, please say something to me. Just one word. Let me hear your voice. Please."

My fingers were turning blue from holding the phone. I was sweating and breathing heavily. I could not think of a word to say.

"Los Angeles, you need to say your sentence; you have half a minute."

I finally said:

"Dad, my dear Dad, I love you. I will see you again."

Click. That was it.

Why was I such an idiot? I could have said something reassuring, such as, "Please don't worry. We are doing great." Or, "Give my love to Mom and Zoran." I had enough time to say that. But I could not even think. I felt dizzy and my legs were numb. It was surreal, unlike anything I had ever felt. On one hand, I was ecstatic that I got in touch with them and that they were alive. But at the same time, more than ever before, I was aware of the unsurpassable, massive distance between us. Not in geographic terms, because it is not so far if you can get on a plane and travel. If you can pick up a phone and call whenever you like, the distance is yet much smaller. You do not even feel it is there. But if you cannot do either, then the distance becomes so vast that the other end seems to belong to some other, strangely disconnected world from our own. That night, I felt Sarajevo was part of that different, isolated, far-away world.

I did not sleep the whole night. I could still hear my dad's words and I did not want to fall asleep and let them dissolve into the harsh reality around me. They flowed still through my ears like the most lyrical piano melody and I wanted to hear every note of it, for I was not sure if that, too, might fall apart or

vanish as so much of our lives had so far. I wanted to call again, but I had to wait for days for my number's turn.

Then I got up, grabbed a pen, and started writing. I wrote for hours, anything I could think of. I wrote about all the details of my life, about America, about people we met. Each new page brought me closer to my family at home, until I could feel I was there, with them, in our living room in Sarajevo, and we were all together, talking and laughing.

One of the people I wrote about first was Ruth Hughes, a woman who would, in many ways, become like a grandmother to me. She lived a few houses down the street from Margaret, who introduced us while we were walking in the neighborhood. We all talked for a while in front of Mrs. Hughes's house, and then she invited us to come in for tea.

I was immediately drawn to everything about her and her home. The house looked like a fairy-tale cottage, with red brick accents on the chimney, white façade, and colorful bushes all around. We sat in the breakfast room, which had little crocheted curtains and delicate flower arrangements in each corner. I gathered from our conversation that Mrs. Hughes had come from England after World War II and was the widow of a renowned California Institute of Technology scientist. She was very curious about our families, culture, education, and work. Without even realizing, I had told her almost everything about us.

"You will like it here," said Mrs. Hughes as Margaret and I were leaving. "But you will go through some very hard times first. That is the order of things."

The way she said it, it sounded so normal, so easy somehow. This surprised me. It made me feel good that she did not say, as many others did, how sorry she felt for us and how we *were*, in fact, in a hopeless situation.

Soon after, I started helping Mrs. Hughes around the house. I discovered quickly that she was not an ordinary person. She had so many unique qualities about her—how she talked and handled herself, how she stood up for her principles, how she persistently worked to get things done her way. Often I could not understand what she was asking me to do, especially when it had to do with odd jobs, such as cutting out the plastic windows from envelopes and sorting out and binding magazines and mail by size and type of material. Or, rinsing dishes in a basin before washing them, so leftover water could be used to water the flowers. I did not understand that Mrs. Hughes was well ahead of her time. Long before

recycling became popular, Mrs. Hughes had it all worked out.

Even if it took her several attempts to explain something to me, she would patiently do so. In the end, it had to be done her way, perfectly. Kitchen towels had to be hung to dry, then ironed and folded in a particular way, not any other.

"You see, Sanja, this part here ought to be slightly larger," she would say, pointing to the edge where a towel was folded over.

"Okay, so this here should be a little bit bigger?" I would ask, wondering why she was making me do it like that in the first place and why she was putting it in all those fancy British words so it sounded like a very delicate and important assignment.

"Because that is how you fold a kitchen towel. And, my dear, we speak English in this house."

Every day, when I would show up at her house, Mrs. Hughes would ask me if we had heard anything from our families back home. And every time I would say no, Mrs. Hughes would almost start to cry. She did not want me to see that, though. She would quickly turn around and start talking about something else. At first, this startled me somewhat, as I did not quite understand how and why she was so emotionally attached to us. She was a very private person and never talked much about herself. Years later, I learned she had lost almost all her family in the Nazi concentration camps during World War II. Thinking about it from this perspective, I now realize she was probably, in some ways, reliving her past through us, and that she felt a great need to help us, almost to the point where we became like the children she never had. As weeks went by, I went to her house not only to work but to go out for walks and concerts with her, to cry if I felt like it, or simply to sit in her study room, have tea, and talk.

A frequent topic of our conversation was schooling. I knew my education was not enough for any job better than clerical or secretarial work. One day, Mrs. Hughes casually mentioned I could look into schools and perhaps bring her admissions paperwork so she could explain to me what I needed to do in case I were to decide to go back to school. I was thrilled with the idea at first, but when I realized how expensive it was for foreign students, I lost the last bit of hope. Mrs. Hughes, calm as always, sat in her study and went over the papers:

"I see. Well, what must be done, must be done. You shall apply, and I will act as your sponsor."

I was not sure I understood her.

"My what? What does that really mean for graduate school?"

She smiled and explained she would set aside all the money necessary for me to complete my master's degree and would pay for all the expenses until I was done. With my eyes wide open, I looked at her and kept repeating:

"You mean, you will pay, you will pay…"

And she kept smiling and confirming that yes, it would all be free for me. I would never have to pay her back.

"You have helped me when I needed it most; now it is my turn to help you."

She concluded the conversation in her typical fashion—decisively and with no room for argument. She got up and handed me the file. Our discussion was over. True, I did help her in the house and took care of her after she had heart surgery, but it was wild to think she was giving me $35,000.

I held my graduate program acceptance letter and let my tears drop on the paper freely. Like many other moments in my life, this one was bittersweet. It was the first big accomplishment of my life in America, the first battle won. How badly I wanted to share it with Mom and Dad! How much I longed to tell them: "Look, there is an open door in front of me; you don't need to worry!" But there was no way to convey the news to Sarajevo. Djeno, Margaret, and I celebrated quietly. We were too scared to let the feeling of happiness overcome us, for in those days we always feared that after letting loose in a moment of joy, there was bound to be bad news quickly following.

Amila, July 1992:

It's been almost two months since we got here. I understand that this is salvation for the kids. They are free to go out, play with other kids, swim…You could say they have a sort of normal life here. But every moment, I find myself thinking about all of them in Sarajevo. If I eat, I feel guilty; if I walk in the sun, I think of dark nights in basements and of their fear. On the other hand, I have to be reasonable. At least they know Adi and Dino are safe here. That is as great a relief for them as it is for me. When I hear stories of three-year-olds being so terrified that they run out of shelters in pure panic, I feel blessed with the situation I am in.

We received your second package, the one with clothes. Please thank Margaret and all her friends who helped collect all these wonderful things for us! Since there were so many nice things for the boys, I gave some toys and shirts to the other kids. We always share everything. All of them were so excited! Adi, of course,

the most! He reluctantly gave away some of "his" things, and he made sure all the other kids know he is only temporarily lending them. When we return home, they have to give them back! I had to talk to him about it and told him he would feel terrible if other kids in our group were getting packages and were not sharing anything. It's hard to explain that to an eight-year-old.

Thank you so much for all the things you sent for me. The pants are great. The shorts, too. A little bit big, but with a nice belt, you can't even tell. I have lost a lot of weight, that's true, but you really did a good job with sizes! Oh, and the swimsuit is just the right size, too! Now I can go swimming with the kids. I don't really enjoy it much (I can't enjoy anything anymore), but Adi and Dino love to go to the beach. Adi is already a great swimmer. Dino is still hesitant, but if I go with him, he'll let go of me at some point for a little bit. Even though he is only four, you can tell he wants to be independent. Generally, both boys are doing fine, I think...

I stopped writing to listen to the news. Can't be much worse. Today was the worst day of shelling since the war began. It lasted twenty-four hours. They brought 151 civilians to the hospitals until 4 p.m. Ten of them already died. The reports say the city has organized some kind of defense, though not very strong for now. They have some light artillery, more than before, and more people are joining in to defend the city. Not really sure how they can do it at all, because it seems to me that every little advancement they make, the shelling worsens. They want to kill Sarajevo, period. And, if you look at what is happening in other parts of Bosnia, oh my God! People in concentration camps, mass killings, rapes—it's as if the world is going back into Dark Ages. I really think the world has no idea what is happening in Bosnia. Maybe it is not their business, but time is running out. The truth has to get to the eyes of the powerful, the ones who could do something about it.

Let me go back to what I was writing...the kids...Yes, all of the refugee kids in our group are fine, really. They are healthy, they eat well, they play, fight, all the usual stuff...We, the mothers, started talking about what we will do if we stay here beyond September. First of all, we probably won't be able to stay together in this house much longer. Where are we going to go? What will happen with school; where are the kids going to go? I still have some money: $160 and fifty Deutsche Marks. I exchanged $40 today. That will have to last for about twenty days, maybe longer, if there are no unplanned expenses. I spend about $20 every ten to fifteen days. That includes fruits and vegetables, bread, eggs, occasional ice cream for the kids, and public transportation (which is not free anymore). Sometimes I think I spend too much; I don't know. I have lost all criteria...I don't buy meat at all. I also

*don't buy any clothes, of course. I figured that, if I have to, I could last another few
months or so with what I have. I hope I won't need a dentist or a doctor, because I
simply can't afford that. And unless it is an emergency, they will not see me for free.
In any case, if I get desperate for money, I will let you know.*

*...I am continuing a few weeks later. I am not sure why I didn't send this
letter before. I miss you guys so much...It's after midnight, and I am sitting all by
myself and writing...Every day has become harder for me to endure. I don't know
how much longer I can handle all this. The situation in Croatia is changing, too.
People don't have as much understanding for refugees as they used to. It's under-
standable. The economy is going down, and people are struggling, including our
hosts. I wish we could disappear from here, but where to...? I know this is better
for the kids, and they will hopefully come out of this with no trauma, if they don't
go mad having a mad mother! Seriously, sometimes I think I am totally losing it. I
have been trying to write a letter to Jasko and Mom and Dad for a week now with
no success. I can't write from my heart, because there is only misery in it. If I write
just plain information, then it's more like a news report, with no feeling whatsoever.
And how can I write about feelings when all I feel is worry, fear, desperation? Will
we see each other again ever? What will be our future? Do I even have a future? I
feel like my life is just completely falling apart...I want to go home! Why are they
doing this to us?*

*...I am continuing this the next day. Sorry. I was sobbing and couldn't
write anymore last night.*

*I wanted to tell you a little bit about our life with our new hosts. I will be
thankful to them for the rest of my life. They really saved us by offering us a room in
their house. It's much more comfortable here. We have a big bed. I cook for myself
and for the kids. I don't use the phone. I hope this will help leave things "clean" once
we are no longer here. I perfectly understand their situation. I know the kids get on
their nerves sometimes, which is hard...I have to keep everything in balance. I can't
afford to do anything that will hurt these people in any way. The problem is that
my nerves are stretched thin, too. Many times, I think I can't stand this one more
day. You will have to excuse me for always whining and crying to you, but you are
the only two people in this world I can say this to at this point...Even thousands of
miles apart, I feel you here. Please, please tell me what to do—how do I manage to
go through this torture? How do I restore my faith in life again? In the future? The
kids are my great joy, of course, but also a great worry. I am scared for them. What
kind of life will they have? How will I provide for them? How and where will they*

grow up? I am trying my best to be a good mother, but I don't know if I am. I don't know what to do...

The good news is Adi will probably start school soon, very close to where we are now. The principal of the school is a very nice man, who accepts little refugees from Bosnia to sit in classes and listen to instruction. Otherwise, the kids from Bosnia are not allowed to go to school here.

By the end of the first war summer, we managed to get through to our families in Sarajevo only a couple more times. The war was escalating all over the country, with no end in sight. For the first time, a horrifying thought went through my mind: *What if the madness continues into the winter?* I immediately shivered and tried to dismiss the thought. I never mentioned it aloud. But it remained.

The letter came. Our immigration interview was set for September 1, 1992, my dad's birthday. Our file was enormous—more than six inches thick—and extremely carefully prepared. Margaret and Mrs. Hughes had been collecting news articles, stories, and other documents related to the Bosnian war for weeks. I had translated all the letters we had received so far, complete with footnotes and explanations of particularly important points. We accumulated so much material that our file filled a big box rather than a folder. I wondered if anyone at the immigration service would actually have time to read it.

The night before the interview, I was jotting down the last notes of what we were going to say the next morning, expecting Djeno to be home soon. The phone rang. A voice said:

"Are you Mr. Kulenovic's wife?"

I sensed something was wrong.

"Yes, I am. Who is calling?"

"Your husband has been in a serious car accident. Don't worry; he is alive, but injured. I am one of the witnesses. Can you please come?"

My body went cold. I scribbled down the location on the pad with my interview notes and stumbled down the stairs, calling for Margaret. Within seconds, we were in her car, driving as fast as we could. A million thoughts raced through my mind. *Could our lives be any more complicated? Is he badly hurt? Where will they take him?* We had no medical insurance. *What if they would not treat him? What if he needed surgery?* I felt myself losing all control. I gave my best effort to calm down and stop my heart from pounding, my hands from shaking and sweating, but I could not. I broke down in tears and gasped for air with each breath. Margaret just kept driving, repeating comforting words over and over, that everything would be fine, but neither of us knew if that was so.

The accident scene looked like an action movie set. Fire trucks, police cars, paramedics, shattered glass all over the intersection. Traffic was blocked in all directions and people had gathered on the sidewalks. We jumped out of the car and frantically looked for Djeno. He was on the opposite side of the intersection. The paramedics had put him on a stretcher and were working on him.

There was blood all over his face and body, but he smiled the second he saw us. *Thank you, God,* I thought.

"I'll be fine; don't worry," Djeno told me. "They think I have broken ribs, but all this blood is from my nose. It's not serious."

Before we could say more, he was taken to the hospital. He was diagnosed with two fractured ribs, other minor injuries, and severe bruising. Luckily, that was all. I felt indescribable relief. The other car had slammed into the driver's door at full speed from the opposite direction. Djeno easily could have been killed. Just the thought of how much worse it might have been was devastating. I could not possibly imagine life without him. I realized this could have shattered our lives even more than the war in Sarajevo.

The car had been totally destroyed and was a pile of junk metal. The steering wheel and driver's seat were displaced, ending up a foot or more from their original positions. It was incredible to think Djeno had emerged from that wreckage alive.

The next morning, our friend drove us to our interview at the Federal building in downtown Los Angeles. Djeno was half-drugged with the painkillers, and I was scared to death. I had to talk and answer questions, and I did not know what to expect. It was the most important moment in our lives so far. We could not afford to mess this up.

The Immigration and Naturalization Service office was overcrowded, as usual. We waited forever for our turn, feeling so exhausted we could not even talk. Djeno's face was so pale I thought he was going to faint. He took some more pills. The air in the room was heavy and stale.

We sat for hours, in silence, holding hands.

"Mr. and Mrs. Kulenovic?"

We both jumped. We surely did not expect to hear "Mr. and Mrs." in this huge room filled with immigrants. My heart rate escalated to a hundred beats in a second. A nice-looking young woman approached us, smiled, and introduced herself.

"I will be your immigration officer. Please follow me."

I could tell she was surprised when she looked at Djeno, but she did not ask any questions. His left arm was immobilized in a splint, the hand bandaged, and there were cuts and bruises on his face and neck.

We followed as her heels rhythmically echoed through the long corridors. She opened her office door and we quietly sat down. Our fate, our future,

our very lives, were in this woman's hands. This was our moment to explain why we were here and to convince her we had no choice but to ask to stay in this country.

She opened the conversation.

"I read your file. I am sorry to hear what is happening in your home country," she looked at us. "I have gone through all the material you submitted, and I am going to recommend approval of your application, unless you say something today that completely changes my mind."

With these words, she smiled and closed the file in front of her.

What was that? Djeno and I looked at each other with our eyes wide open, in complete awe and disbelief. Did we understand correctly? We knew well what the word "approval" meant. Could it be? Was that all? No tricky questions and tough explanations? Nothing? We are approved? I squeezed Djeno's hand under the table. After the long experience and anticipation of so many difficulties and problems, everything came down to this one moment. All our worries disappeared with a single sentence.

She noticed we were reluctant to show any emotions and that we were still apprehensive. We just stared at her. She smiled again and asked us a few more questions, merely to keep the conversation going and to call this "an interview." We answered as concisely as we could, for we did not want to say even one wrong letter, let alone a wrong word.

We had no reason to worry. A few more formalities and it was over. We were led into a different room where we had our photographs taken, and in no time we were walking out of the building with two little plastic cards with our names and signatures and the most magical words on the front: *Authorized to work in the United States of America.* I looked up to the sky, thanked God one more time in two days, and wished my dad a happy birthday. I knew that, even though he did not know it, it was the best gift anyone had ever given him.

The next morning, we opened the classified section of the *Los Angeles Times* and started looking for jobs. We were well aware we were not in position to pick and choose. We circled all the advertisements that looked reasonable and counted them. More than fifty. Good start. Perfect, actually. We figured that at this rate each week, there would be plenty of opportunities and promising chances of each of us landing a job. There had to be a place in this big city that would employ at least one of us. We just had to be patient and persistent.

A few weeks later, on a hot summer Friday, Djeno left early in the afternoon to apply to several restaurants, car washes, and machine shops in the neighborhood. It was an ordinary day in which we did not hope for much at all, but we kept up the pace of applying to at least a few places every day.

I was vacuuming when he walked in.

"Hey, Sanja, hey, hey!" Djeno was trying to be heard above the noise of the vacuum cleaner. He came up to me and shook my shoulders.

"Sanja, I got it! I got the job at the pizzeria! It's gonna be at least seventy-five a week!"

"What? Don't joke with me—are you being serious?" I stopped vacuuming and looked at him closely. His eyes were so bright and his face lit up with joy.

"Would I joke about that, what do you think? No, I got the job, Sanja; I am not kidding! Seventy-five dollars a week, at the minimum!"

We hugged each other and started jumping around the house like little kids. I could not believe how *rich* we were going to be. Seventy-five dollars a week! If he got tips, it was going to be even better. We immediately started making plans as to what we would do with all this money—how much we could save up, how much we could send to Bosnia…on and on the whole evening, as if we had just won millions in the lottery.

Many times later, we would remember this night as one of our most precious memories. Never again, even after getting well-paying jobs, did we feel the same amount of joy, the thrill we did on the evening we became aware that we could, in fact, earn money to survive. Promotions, titles, and good salaries that would come later in our careers never came close to Djeno's first $75-a-week pay.

Within a couple of months, we had a whole series of jobs. We bought another used car. We joked a lot about the new "professions" we had acquired: Djeno was an expert driver, and the best living guide for the Pasadena area, including detail on who lived in which house, who gave the best tips, and who did not tip at all and therefore was condemned to be the last to receive pizza on a round. During the day, he worked for a courier service, delivering checks to businesses and banks. He was also becoming very proficient at gardening, something he had never done and had absolutely no interest in learning, but it paid $5 an hour and could be done on the weekends.

I became a student again. Additionally, I was a professional at washing dishes, scrubbing bathrooms, cleaning floors and garages, cooking, and

performing all laundry services, including the careful ironing and folding of kitchen towels at Mrs. Hughes's house (definitely a favorite). In the area of babysitting, I was the perfect choice in the neighborhood at a rate of $4 per hour for two kids. However, since my highest expertise was in the domain of house-work, I began working for a disabled old lady who could only pay me for two hours a day but needed so much work done that it could hardly fit into five. The bill: $10 every day.

With all the money we were now earning, we decided it was time for us to move out of Margaret's house. We found a cute apartment in a not-so-cute neighborhood, but we did not care. The place was small but clean and cheap. The owner was reluctant to rent it to us, not surprisingly. We did not have any credit history or credit cards, and we had not held jobs for more than a couple of months. Somehow, we had to convince her we were able to pay $500 a month for twelve months.

"Trust us, we have tried to establish ourselves here," we told her. "We had applied for a credit card so that we can start our credit history, but we were denied because we didn't have any credit history. How do you even start?"

She could not argue with that.

We told her the two of us were educated people who just happened to be temporarily stuck in this situation and the fact that we cleaned other people's houses and delivered pizza around town did not make us any less responsible or less worthy, for that matter.

After a few days, she called us to say she agreed. We signed the lease.

Today, we left our first home in America and started living on our own, I wrote in my journal. *It didn't take us a whole lot of time to move, because we don't have much. We fit everything in our car. Margaret gave us a mattress, linen, and some pillows. We borrowed a couple of chairs and a folding table from Mrs. Hughes. We have some pots and pans, a couple of plants, and some books. That is really all we need for now.*

It'll be a bit weird to wake up here tomorrow, not in Margaret's house. We are so used to living with her. It was our only home and we felt safe there. This is a little scary now…but I feel great that we can afford our own apartment. I am so excited. We are now average middle-class people.

Goodness knows how far the two of us were from belonging to the

middle class and how ridiculous it was to be thinking that way! But we were so thrilled with every step we made toward being independent and creating our new life that what now seems like a relatively small accomplishment was a gigantic step forward back then.

On the other side of the globe, for the people of Sarajevo, winter came early.

My cousin Nadira, November 1992:

I want to tell you what a typical day in Sarajevo looks like: Provided that you slept in your own bed, and not in the basement, you debate how you can jump and put on three to four extra layers of clothes in the fastest way possible... You don't take off the clothes you sleep in, to spare yourself from the shock of putting them on again in the evening. After going to Siberia (that's the bathroom), you wash up with a glass of water, if you have it, and if it didn't freeze during the night. But, listen to this: We have WARM water in the morning! As the genius I am, I put some water on the little stove in the evening and pour it in a thermos bottle. Put the bottle in bed with you, the next morning, voila—the water is still warm.

After you have washed up, you eat. No surprises on the breakfast menu at all. Bread, Bread, and Bread, his majesty Bread, with a capital B. You either spread a thin layer of Margarine (also important to put a capital M) on it, or you just eat Bread. On a special, luxury occasion, you might be lucky enough to get ten grams of feta cheese in the humanitarian package. By the way, humanitarian aid is about as frequent as the airline traffic in and out of Sarajevo, so you don't count on that feta too much. Oh, I forgot to mention one important rule of life here: You never look at the thermometer. If you are aware of how cold it really is, it makes it a lot worse.

Next, it's time for our regular exercise program, "work and war victories": who can find wood, who can chop it and carry it, who can make the best fire, who can cook dinner out of nothing. You get bonus points for staying alive. If you happen to have a neighbor who had somehow already filled up his balcony with wood and is burning it the whole day, then you may skip the exercise program altogether and resort to the second activity: sit with your neighbor and do nothing all day. Mom and I, however, like exercising and working, so after the morning aerobics, she goes to work (to the "Ice Castle"), and I cook dinner. This activity has a few variations, too: You can open a "surprise can" (you never know what kind of "stuff" or what kind of smell you are going to find), or, if you have one, you can open a lunch box. We have some lunch boxes that taste like soap and smell like a paper factory.

Seems to me like you can die just from reading the ingredients, let alone from eating them. The good part is that our tummies are trained to accept even stones these days. If you take a can, you also have a luxury lunch option: If you have a little bit of onion and lentils, oh! What a delight! Of course, you only use half a can. The other half you leave for the next day, and you immediately say a little prayer to be alive the next day to eat it. If you have absolutely no other options, you eat rice. You can make a rice pie, a rice soup, rice patties, you name it. It's basically all the same, but you feel a bit better if you call it something different. There are also other delicacies, such as mayo with no eggs, pate from breadcrumbs, "French fries" from corn meal, and all sorts of cakes with no sugar, chocolate, nuts, or butter. One day I can show you my new culinary expertise. The only problem is I am not sure how I will do when I actually have all the ingredients! As you might have noticed, I am still hoping I will live to see that day.

After dinner, well, that's when problems come. Can't read, can't draw, can't knit. Can't talk anymore, 'cause all the talk is about war. The evenings are really long.

I realized, in the midst of all this, how adaptable human beings are. Remember how picky I was with food? That changed in a week. Think you couldn't get used to living without water or power? Yes, you could, faster than you think. Imagine how easy it would be to get used to some GOOD stuff in life, like traveling or living in a beautiful house. Mom keeps saying everything has its good and bad sides. I am not sure if that applies to war, but maybe it does. Maybe we will "grow up" in some ways and be more appreciative of life itself.

The lentils smell so good. Enough for now!

My aunt Satka, Nadira's mother, November 1992:

Nadira told you about the Ice Castle. That's our pediatric office, the only one in this part of the city. I just came back from there, sat down, and cried for hours. I cried all the tears I had been collecting for months. Nothing particular happened, I just couldn't hold it anymore. I wonder if I will ever be able to feel any happiness after the bitterness I feel now. I doubt that life can bring me any joy at all. The little I had left in me is gone. Sometimes all I want is to somehow send Nadira out of Sarajevo, go to bed, and die.

I had a few sick kids in the office today. Mostly frozen fingertips and ears. My hands are swollen, too, but I don't yet have huge problems. What amazes me over and over are the mothers and kids who come to my office, especially babies.

They are all clean, their cloth diapers as white as snow. You wonder how these poor women wash them in this kind of weather...but when I see their hands, it becomes clearer.

This past week was UNICEF's "Week of Peace for Children." They had promised to deliver baby food to hospitals and clinics around town. We had hoped for a lot, but we got almost nothing: Every other child got one pound of formula, which lasts for about three to four days. We urge mothers to breastfeed as long as they can, but even that, with the poor nutrition they have, is nothing. Many kids suffer from protein deficiency and anemia. Medicine that came as part of this program is another failure. Can you believe we received antimalarial drugs? Isn't it obvious that we are not Africa and that we aren't concerned about mosquito bites in this freezing weather?

I just heard that a bomb was dropped on the crowd waiting for water—six killed, twenty wounded. They hit the bus that was taking fifty kids from the orphanage out of the city—a two-year-old girl and a one-year-old boy were killed. They will kill us all. Or we'll just all die from the hunger and the cold.

The worst part of this war is that people feel abandoned by the whole world. There are so many different humanitarian groups, agencies, journalists, and soldiers here, yet it's getting worse for us all the time. One official recently said the situation is not that desperate: They had estimated that 200,000 people would die of cold and hunger, but only forty percent of that number actually did! I can't understand how, in today's world, with so many powerful weapons, nobody wants to help lift this siege—it's not as if we are somewhere at the edge of the world.

I feel as if I am at the bottom of hell. Even my childhood after World War II was luxurious compared to this. It was hard, but at least we had water and food. We could go out and walk. Now the city reminds me of a ghost town. Remember descriptions of occupied towns from the eighteenth-century history books? It's like that. You see young people on crutches, old people carrying containers in one hand and a few small branches in the other, walking by and asking you if you had seen water, food, or wood anywhere. Piles of garbage litter the streets. Stray dogs sniff at them, looking for food. Everything is gray.

At night, when there are no lights, you feel all alone in the whole world. You can't imagine there can be such darkness in this city of hundreds of thousands of people and such an overwhelming feeling of isolation.

Sometimes, Nadira and I talk about what some of you might be doing at the moment...who is enjoying dinner in a warm kitchen, who is walking around,

who is going to a movie or a concert. Then we start laughing, thinking what you would say if you saw us. For example, I am wearing Nadira's ski boots, three thick sweaters, and a jacket. My hair is entirely white—I don't have enough water to dye it. I tried melting some snow, but it was so dirty I couldn't do it.

Dinner tonight was awful. I don't know what they are giving us in these cans, but it can't be good…I wanted to wash if off with water, but even the water tastes bad. I need to boil it first, but that is hard with the water-clogged wood I have and freezing temperatures, even indoors.

I am watching Nadira as she writes her letter. The light is almost gone, but I can see how her face has become older, overnight…Every night she says: "Thank God, one more day is over." That's not how it should be for a twenty-year-old. But our days are all the same. We don't have anything to look forward to. It's been nine months since we became victims of these criminal games, and we don't have any more strength. At the beginning, all our reactions were so intense from all of our emotions and all of our fear. Now we hardly notice things. I can't say we got used to this kind of life, because this is not life, but whatever it is, we are used to it. We eat and drink because we have to; we sleep when our bodies collapse; we pause for a moment when we hear a detonation, knowing some poor soul was just killed, but we thank God it's not us, and we go on.

People's imaginations and creativity make life much more than pure existence. What makes life interesting and rich is the freedom to go out, socialize with people, laugh, travel, see a play, learn something new…That's what we miss the most. That must be why people talk so much about the past and their memories from before the war, even though they can be extremely painful under current circumstances.

Finally, it arrived. A plain blue envelope postmarked in France in my mom's perfect handwriting. After eight months of war, the first letter from my parents and brother arrived. I quickly moved around other mail and picked up the envelope as the greatest treasure. I touched the ink where my mom wrote. I felt strange.

My dear child,

I have been talking to you in my mind every day. If there were a machine that could record my thoughts about you, you'd have books to read forever. Now that I finally have a chance to write you a letter, I don't know what to say. I thank God and Margaret that you are not here. Please tell her that I have absolutely no words to thank her for everything she is doing to help you. I will not forget that as long as I live.

I miss you so much that sometimes I think I can't take it anymore. Then I go to your room, look at your pictures, talk to you, imagine where you are and what you are doing...and cry my heart out. I know it's not rational, but I can't help it.

We celebrated the great news about your school and your job. For that occasion, I made a special meal: chard leaves stuffed with rice and chopped canned beef. I made soup from the stems. Yes, I know, it is far from our celebrations in the old days, but four chard leaves are comparable to caviar these days. We also had a bottle of wine that we saved from who knows when. We ate early because we don't have any candles. I made our dinner table pretty, with a nice tablecloth, cobalt plates, and crystal glasses. We wanted to make it special for you. Even though all three of us had tears in our eyes, we toasted you and Djeno and wished you all the best. Please, don't be homesick. Understand that Sarajevo is not the city you knew. It is nothing but another word for hell. All your friends are trying to leave, if they haven't left already. People risk their lives trying to escape the city, as if they were criminals escaping from a high-security prison, not just regular people. Many are killed, running across the airport runway. Yet, those who do this to us day in, day out, walk around freely. There is no justice in this world.

I can't begin to explain what we have endured. I haven't gone out of the house in months. Alija and Zoran have to go out to bring us water and food. Saying goodbye when they go has a completely different meaning now than ever before.

Every time they leave the house, chances are high that they may never come back. My whole body shakes at the thought. When I hear a detonation while they are gone, I think I am a step closer to going mad.

Some time ago, it was one of those hard days. I was home by myself. Alija and Zoran went out to bring water and to see if they could get anything at the market. Bombardment started almost as soon as they left. First, one blast every ten minutes or so, but then more and more often, until I could hear a whistle every minute. By the sound of it, I knew they were targeting the old town. It was close. I started thinking of the routes Alija and Zoran might have taken. I can't tell you how many different scenarios went through my head and how they drained me. Just when I thought I'd go down to the basement, to be with other people, someone knocked at the door. It was our friend Ibro, the painter. As I opened the door, he almost collapsed at our doorstep. God knows where he had been and how he made it to our house, but he could barely stand. He crumpled onto the floor in the hallway without saying a word. He was exhausted and visibly distraught, his shirt drenched in sweat. I quickly poured some water for him to drink and wash himself. After half an hour, he calmed down and was able to talk. He said the National Library was burning. They struck it with fire bombs—can you imagine? They wanted to destroy the beautiful old library and all its treasures—centuries-old rarities, books, documents, the whole history of our people, our culture. To remove every bit of proof that we ever existed in this world. You know that the library stood there forever and survived many cruel wars. Even the Germans didn't destroy it. That tells you a lot. That is the "war" that is going on here.

Ibro said that after the library caught fire, they slammed bombs all around it so nobody could put the fire out. That's what I had been hearing all afternoon. People who happened to be there formed a chain trying to save at least some of the valuables, passing them from hand to hand. One librarian died.

I didn't know if I was shaking from fear for Zoran's and Alija's lives or from the deep disgust I felt. I never went to the basement. Alija and Zoran came home later in the day and Ibro stayed overnight. He drew some sketches. I saved them.

The library burned that whole day and night and into the next day. We couldn't sleep. It was hot and the air smelled of smoke. We watched the bright red sky, illuminated by the burning books. It went on for two more days and nights until only the bare walls remained. Little pieces of gray papers fell on the city for days. Our heritage, our history, an irreplaceable part of us, reduced to ash.

I am sorry I have to write you this story. I know it's hard for you to under-stand all this. It must be hard to watch the news, too. I wish I could have written to you something else, but you wanted to know how we live. This is our reality now. Keep in mind, though, that we are doing all we can to be extra careful. We have hopes that this nightmare will end soon. It can't go on forever. Also, always remember that the situation for us is much better than for people in many other parts of the country. At least we are still in our own home.

I have to add something even though it has gotten completely dark. I will not have another chance to wish you a happy birthday. I want you to know that we will celebrate it no matter what. I have saved a handful of walnuts and I will make halva. My dear child, I wish you all the happiness in this world and I live for a day when I will see you again.

My dad, November 1992:

My dear Sanyushka,

I am rewriting a letter I wrote two nights ago. We haven't had any power for two months and we were out of candles, so I did a very poor job of writing in the dark. All I had was a wick in a glass filled with three-fourths water and one-fourth oil. That hardly gives any light.

I know this must sound like fiction, because it's hard to comprehend this reality. You must be thinking this is life as it was a century ago...It is. The only dif-ference is that a century ago, people didn't know any better, and this time around, it's a complete torture.

But here we are...surviving.

We still occasionally have gas, and when we do, Dzaja makes bread on the stovetop. We are entitled to one 400-gram loaf per day (from humanitarian relief), but it is not enough, considering that bread is almost all we have. Plus, we don't always get it. We don't have milk, cheese, fruit, eggs...We haven't even seen, not to mention eaten, tomatoes or peppers in seven months. But we are lucky to have anything. We had stocked up on flour, sugar, rice, oil, and salt while we could. Sometimes we get a can or two from the humanitarian relief. Vegetables (if you can call individual cabbage leaves and other, unidentified leaves that), you can still buy at the market, but you risk your life going there for it. A few months ago, you could still get spinach and lettuce. If you have a lot of money, you can buy onions for $15 per pound. One onion is quite a treasure. Dzaja can make a few delicious dinners with it. You know she has always been a great cook, but now she has become a master chef.

Since winter is here and there is no end to the power outage, we bought a small handmade stove and installed it in the living room, where the TV used to be. The stove is old and doesn't work well. Of course, we can't heat the whole house with it, but at least we can boil water and make a meal. We still have wood, unlike others who collect branches and little pieces from fallen trees. Our walls are dirty from soot and smoke, less where paintings used to be, and the whole room looks bleak, but that is the least of our worries.

The situation with water is no different. I have developed a system of carrying as much as possible in one trip. I put two smaller containers in a bag over my shoulder and carry two more. It is easier to carry two equally heavy containers in two hands than to carry only one. I get tired just the same, but I balance better. It's not an easy task for your old man, but I have to do it. The worst part is when I cross the bridge—or what is left of it—and that is a single beam, five inches wide, and a metal railing. It's easy on the way there, but on the way back, it's hard to balance. And I don't want to drop my containers because we don't have many anyway. I hold onto the railing with one hand, and take the containers across, one by one, in the other. So, each trip takes at least three crossings on the return, six times back and forth on the "balance beam"! And that is enough water for about three days if we ration it. People joke that it would be weird to fall down into the river and be killed carrying water. But I don't think about it. Many are scared to go across, so they walk to the other bridge, which is much farther but more exposed to sniper fire. If I could choose, I would rather fall into the river than be shot by some idiot's sniper bullet. I am fine going across, not dizzy or anything, plus all this physical work has made me stronger. I don't feel sixty-eight at all. I am too busy to think about it. I have to be positive and hope our fate is to come out of this alive.

Please write if you have a chance. Love you more than anything.

Zoran, November 1992:

Mom and Dad already told you a lot about how we live now. I'm going to add a few words about myself. Right now, I still have to report to work, but only a couple of hours a day. After that, I am free to go. Unfortunately, you can't go anywhere. There are some cafes open during the day, but they are a target, so you don't go. It gets dark early and there are no lights in the streets at all, so you have to be home by five. It's indescribable how dangerous it is to move around. Before we lost power, I used to go to my friend's house to learn AutoCAD. I know some basic

things already. But just when I thought I was getting better, the electricity went off and never came back.

Days are all the same. It's as if someone has frozen all normal things in life. You don't know what to do, you can't read or write in the dark, you can't go anywhere, yet you are happy if there is no shelling, so eventually you can go to sleep. If it's heavy bombardment—one bomb every few minutes—you don't have any choice but to go down to the basement with neighbors. But, even there, you are not safe. The other night, we were all standing in the pitch dark at the stairs, along with another fifty to sixty people, when a bomb hit our building and went right through our neighbors' dining room. I had thought I knew how powerful these things were. But it was one thing to hear it slam into a building farther away and different to feel the detonation under your feet. It felt like a magnitude-eight earthquake or something. I completely lost my orientation, couldn't tell for a couple of seconds where the ground was. The explosion was so huge it blew out all the windows on the building. Nothing is left of our neighbors' room. There is a huge, gaping hole in the outside wall—and you know how thick those concrete walls are—you can see it clearly from down the street.

We all fell to the ground. I can't tell if we fell because we instinctively tried to "hide" or if the detonation threw us all down. I knew Mom and Dad were close, but I couldn't see them in the dark. After a few moments of half-silence, and I say half because I didn't hear voices but I did hear glass breaking and walls collapsing, everybody started yelling at the same time, trying to figure out who was where and if anybody was killed or injured in the blast. It took me more than half an hour in total darkness to figure out that Mom and Dad were alive and okay. Mom was shaking badly and crying hard, almost hysterically. I had never seen her like that before.

People keep saying this madness will end before real winter starts. We'll see. I am trying not to hope too much. I just wait and dream that one day I can come to Los Angeles and drive on those freeways you talk about.

I am glad you guys can work now. I bet it's hard to get used to everything there. But, hey, don't complain—just thank God every day for the warm weather you have. Love you, Zoran.

I read the letters several times and then again. And again the next day and the day after that, until I had memorized every word. I read them slowly, try-ing to discover hidden meanings, analyzing handwriting, wondering what caused

skewed lines or distorted letters. Was it a sudden loss of light from the wick? Or a detonation that made the writer tremble? I lay in bed picturing the letters in my mind, whispering the words, imagining what my mom, dad and Zoran were feeling and what they looked like. I knew they were not entirely honest with me. As much as they tried to tell me all about their lives in the war, I knew there was a lot more than they were willing to share. I knew them too well. My mom did not tell me she cried every single day. But I knew she did. I could hear her quiet sobbing in my dreams. I knew how much she wanted to pour out all her feelings, to tell me of her long sleepless nights and her worries. But she chose to tell me the story about the library. Zoran did not tell me he sat for hours every day not wanting to say a word to anybody, keeping his thoughts to himself. But I knew he did. I could see his face and his eyes. My dad did not tell me how humiliated he felt when he bought four chard leaves at the market. But I knew it was almost worse for him than to be shot. Instead, he told me how strong and able he was with crossing the river with heavy water containers.

As I had many times before, I admired my family for being who they were—composed, dignified, and proud human beings. Even with their lives reduced to bare survival, they remained themselves. They lived their lives beyond it all.

Along with my family's letter came the November 1, 1992, issue of the local daily paper called *Oslobodjenje*. My dad said it would give us an idea of life in the city. I looked at the few pages of faded print. It was black and white, with few pictures. Under the newspaper name, a few words in bold type: Bosnian War Chronicle. Then, a cartoon. A man standing in the middle of falling bombs and a voice from outside yelling: "Get ready! Today is November 1—Day of the Dead!"

I looked at the articles: "Sarajevo in Siege: Darkness Until Further Notice;" "Message from Audrey Hepburn, UNICEF Ambassador—Week of Peace for Sarajevo Children;" "One Package of Baby Food per Child;" "At Hell's Door;" "Beans for City Defenders;" "Old People's Home: Residents Frozen to Death;" "Plastic Sheets for Windows Arrived;" "Sarajevo's Black Saturday—Hospitals and Mortuaries Full."

It was like walking into a nightmare, wrote Peter Maass, a western journalist, after visiting Sarajevo's Main Hospital. *I trained myself to resist the temptation to look where I should not look, to not glance into open rooms where, I sensed, someone was dying, or having shrapnel removed from the abdomen, or losing an*

arm to amputation. When I interviewed patients, I tried not to let my eyes focus on the soiled bandages sticking onto their wounds, or the bloodstained sheets tossed under their bed, or the rows of metal rods poking out from their shattered limbs. I controlled my breathing, too, trying not to inhale deeply, taking shallow, even breaths, thinking that this would prevent the diseased air from reaching the core of my body. I could last for no more than half an hour.

My aunt Fahra, December 1992:
We are alive. They say that a person is healthy if there is physical and psychological balance. According to this, I am not sure I can say we are healthy. The most important thing, however, is that we are still "in one piece." Our home is half-destroyed, so we are staying with relatives, as you know. A bomb hit the bedroom and set it on fire. Luckily, the neighbors saved it from burning down completely. We cleaned as much as we could, but we had to leave. It's impossible to live there until it is fixed, and Grandma has to be in a warmer place.

It may sound ridiculous, but I am still going to work. We work in shifts, every third day for twelve hours at least. I want to stay alive and healthy enough to help the wounded. You cannot imagine how many there are. If I wanted to tell you about all kinds of wounds I have seen so far, it would take many letters…and you don't want to know. But I have to tell you a story of what recently happened at work and what an accomplishment it was for us under these circumstances.

One of my lab colleagues made it out of Sarajevo and is now in Sweden. She sent me a message through the International Red Cross asking me what I needed the most—she said she would try her best to send it to Sarajevo. I asked her to send me two specialized dishes for anaerobic bacteria isolation. You might think I was crazy. Out of all the things I could have asked for from the outside world, I wanted the dishes to grow bacteria. We needed them badly. War wounds are specific—they might contain seven or eight different bacteria—and it is crucial to examine them microbiologically so we can apply proper treatment and prevent deadly infections. I knew my friend would understand how desperate we were. She knew what it meant to run a lab without enough power, water, chemicals, basic material—and at the same time be a favorite target for bombs and snipers. And guess what! A small miracle happened a month later—we got the dishes.

We still have regular lectures, exams, and labs. Students are coming as much as they can. Today we had a graduation for the twenty-three Ph.D. candidates.

I know it is hard for you to imagine, but we even have some theatre per-
formances. People come in great numbers, and places are packed for those occa-
sions. Can you imagine waiting in line to get bread, as if you are homeless, and then
going directly to the theater? Somewhere there, you might have to think of a route
to take to avoid snipers. But when you get there, you feel like a different person.
You forget the reality around you, the kids who can't run around, sing, and laugh.
You become a happier, stronger person and almost start believing in the end of this
nightmare. When it ends and the reality comes back, I realize that, if it weren't for
making other people's lives easier, it wouldn't be worthwhile for me to live anymore.
There is no future to look forward to, and life has lost its sense.

Grandma is doing well. She is eighty-five now. It breaks my heart that
she has to go through this at her age. A few minutes ago she came to me and said:
"Please sit here and take my hands in yours. Maybe it'll be warmer for both of us."
It is minus-twenty degrees Celsius outside, and we have a small stove and a couple
of pieces of wood. I did as she asked and said that I know this will soon be over. I lie
to her all the time to make it easier for her somehow. I have to give her strength to
endure this.

When I see my students, I often think of you and imagine how going to
school must be so rewarding for you. I don't know if I can say that for my students,
who, in spite of bombing and everything else, always come to lectures on time. I
think of little kids who have "grown" during this war time. All of this, unfortunately,
is part of their childhood. Words like war, bombs, killing, should not be something a
three-year-old learns, even before they know how to pronounce the letter "r." Every
time I see them running to the shelter, or not sleeping because they are scared, my
heart breaks.

So, please live life to the fullest, take care of your family and friends—those
are the most important things. I think very often of all the dinners, picnics, and trips
our family has done together. We didn't know how valuable all that was. Now we
know and we must appreciate it, and invest in it in the future, if we are still around.

By the end of 1992, the siege of Sarajevo had lasted more than 250 days. In the last three and a half months that year, 1,200 Sarajevans were killed by shells or snipers. Many others starved to death. "Unless 240 tons of food goes into Sarajevo every day," warned Sir Donald Acheson, U.N. health official, in October, "children will begin to die of starvation in about four weeks' time. Adults, four weeks later."

During December, forty-five residents of the last functional convalescent home in the city died from extreme cold. Their frozen bodies were piled up in utility closets where temperatures were below zero. The dead were buried everywhere, as it was too dangerous to gather for funerals. City parks, backyards, soccer fields, even areas in front of apartment buildings became graveyards as each new day arrived.

Sarajevo, once a beautiful, lively, picturesque city was now the personification of human misery and suffering of massive proportions, a grand example of "urbicide"—a term defined as a "deliberate attempt to kill the city."

In other parts of Bosnia, the situation was even worse. Nobody knew for sure what was happening in the small villages in remote parts of the country, but first reports of forced deportations, torture, and beatings had made the news. "Civilians, women, children, and old people are being killed, usually by having their throats cut. If only ten percent is true of the reports from ham-radio operators, we are witnessing a massacre."[5] For the first time since World War II, the term "ethnic cleansing" was used to describe events taking place in Bosnia.[6] Forty thousand people had already been killed, and the war produced 20,000 new refugees every day.

The magnitude and severity of the animosity there did not seem possible to me. I seriously started questioning myself as to whether I was oblivious to what had been going on for years in Yugoslavia before this war. This hatred could not have come out of nowhere. But I had grown up in a typical Sarajevan family, where we assessed people based on their values, not on their great grandfathers' religion. So, how was it possible, I asked myself, to live alongside these monsters and not know about their existence? Who are they and who raised them? Or, can

people actually become them at some point, driven by forces of nationalism? If so, what drives that force? Is the line that separates barbarism from civilization so thin, almost transparent?

My mom, December 1992:

My dear child,

I have the most incredible news for you. The packages you sent via France are not lost. They arrived in Sarajevo and we picked them up!

I can't thank you enough. I truly can't, because there are no words in any language that can fully explain what we felt when we opened it. This is a gift from heaven to save us this winter. Yes, that's what it is. I have no idea how much you paid for it, but it is worth more than $2,000 here. It is huge—I think it weighs more than a hundred pounds!

When we found out that the packages came, Alija and Zoran left right away to collect ours, because we were scared that somebody might steal it. When they got there, they realized that the package was too big to be carried for more than two miles, most of it uphill. So, Alija stayed with the package to guard it and Zoran walked back home to get your old snow sled and some ropes and belts. They put the package on the sled, secured it, and that's how your biggest gift ever made it to our house. You would not believe what people went through to get packages to their homes. Alija told me that on the way home, they saw this poor old man shot by a sniper, his package untouched on the street, next to his body. Some people were simply too weak for the task—others used strollers, sleds, skis, improvised "vehicles," anything with wheels or that could be pulled or pushed over snow. You can't understand what a treasure these packages are…and I hope you never understand what it is to be starving.

I have to tell you what's in it: twenty-four big cans of vegetables, forty pounds of margarine, twenty pounds of flour, fourteen big cans of beef, twenty pounds of sugar, two pounds of coffee, two pounds of milk powder, baking powder, yeast, two tubes of toothpaste, and shaving cream. As you can tell, the content of the package is incredible. It will last us the whole winter, if we are still alive.

We are so thrilled that we got some candles too, as we haven't had electricity for months. Since we have so much margarine, Satka is trading hers for wood at the market, which is fantastic, because wood is sold at $130 per cubic yard (and most of it is wood from the city parks). She also "bought" a small stove with margarine. I am so happy for her, because both she and Nadira would have frozen

to death if it hadn't been for the margarine from this package. You should feel great, because you saved some lives around here.

Thank you again, my dearest Sanyushka.

On the last day of December, as I had always done before, I sat by myself reflecting on the year's events, recalling moments I liked, analyzing those I would have liked to change, and generally trying to decide if, overall, I was happy with the past twelve months of my life. This time, however, it was not that simple.

There were not too many things I liked in 1992, I wrote in my journal. There were too many I would have wished to be different. But, worst of all is, I can't see where this last year is taking me. My life took such a sudden, strange turn without my will and consent, and I can't do anything to change it or to steer it in any different direction. I feel I am not in control of it anymore and I find this difficult to comprehend. Before I found myself living in America, I had always believed that my choices were the major driving forces of my destiny, that my life would eventually shape up into some form that I had envisioned in my mind and worked toward accomplishing in my own ways, on my own terms. Maybe this thinking resulted from my youth and somewhat naïve and idealistic perspective of life, or maybe from the fact that until now, I had, in fact, been in control of where my life was headed. But on this warm December evening in California, halfway around the world from home, I learned that this is not how we walk through life in this world. I am suddenly aware that I can do little to move my life in any direction other than the one it has somehow taken on by itself, without my having any say in it. The more I think about it, the more I believe that all of us have some predetermined path we unknowingly follow, and that the shape, form, direction, and curves on that path had previously been carved out for us. Whether this is called God's work or destiny or something else, I can't tell, but I know that it is too big a force to fight. I have to let it go.

I looked down at the street. It was busy and full of people preparing to welcome the new year and to watch the Rose Parade the next morning. I listened to the cars passing by and thought of what it would be like to hear detonations and bombs falling at that rate. It might have been how the new year was "welcomed" in Sarajevo. The pictures I did not want to see started moving like a film in my imagination, and I could not break free from them. I went to sleep hoping to see my parents and brother in my dreams. That was all I wished for on New Year's Eve.

PART II

1993

It was February 15, 1993. The phone rang at my desk in a small engineering firm where I worked as an assistant. I knew it was Djeno. He always called before leaving for work, to tell me if we had received any letters from home.

"Can you talk?" he asked quietly.

The second he spoke, I sensed his nervousness. His voice was trembling. My stomach immediately went into a knot. We had never talked about this, but both knew terrible news from home could come at any time.

"There is a letter addressed to me from Immigration," he said.

"You mean…from the Federal INS?"

"Yes, yes, from them."

What could it possibly be? It was too early to expect an answer to our applications, and everything was in order with our work permits. At least we thought so.

I could hear the paper ripping. I asked him to hurry.

"Well, here, I am reading it as I am talking to you: 'Dear Mr. Kulenovic, your application for permanent residency in the United States has been G-R-A-N-T-E-D as of February 10, 1993.' What does this word mean?"

"What did you say? 'Granted'?" I slowly repeated the word.

"Yes, 'granted' is the word. Do you know it? Is it good or bad?"

"God, Djeno, I am not sure, but I think that means you've been approved, but it can't be…"

Neither one of us could register it at first. It was unheard of that the decision would have been made so quickly. It had only been six months since we received work permits. People wait years to have answers on their immigration status.

"Sanja, are you sure? I am gonna check in the dictionary. Hang on."

I really was not sure. I asked him to repeat the word, to spell it in English, then to spell it in Bosnian. He started reading definitions.

"To bestow or confer…What does that mean? What is 'bestow'? And 'confer'?"

"Don't know those words either," I said. "Go on, go on."

"To admit or concede…to agree or accede to, as in 'to grant a request…'"

Then, our conversation paused for a moment—and then we got it. We *got it!*

I started shouting over the phone and everybody in the office looked up. Although they did not understand a word of what I had said, from the expression on my face they knew something extraordinary had happened.

Helen, an acquaintance and our office secretary, happened to be walking by. I got up, almost knocked over my chair, ran to her, and gave her a big hug.

"Helen, do you know what this means?" I shook her shoulders, shouting, "We are allowed to stay here! We will be legal permanent residents!"

"So…what?" Helen looked confused. "You live here already."

She probably did not even know what we had applied for. I jumped up and down in front of her, but she stood there thinking I was a little crazy—after all, don't we all have these rights and privileges? Isn't that normal?

She soon walked away from me and did not share my excitement at all. I understood. I felt the same way when I lived in Yugoslavia. I was an ordinary citizen. I never thought that one day I might be a stateless refugee asking a foreign country's immigration service to accept me. Like Helen, I did not understand that these things were not a "given" in life. Only when I had lost them did I learn how valuable they were.

I walked out of the office and took long, deep breaths in the bright morning sun, trying to slow my racing heart. I closed my eyes and let my mind absorb this huge moment. Green card, in-state resident graduate school tuition, permanent authorization to work, citizenship…perhaps this might lead to something as bold and daring as bringing my brother here if he could ever escape. I stood there in the sun for some time, dreaming of so many opportunities that lay in front of me, so many wide-open doors. I was ready to walk through.

When we were children, Zoran and I fought a lot. He was three years older and much stronger, and I hated how he would always turn things around his way. Our personalities could not have been more different. We never played together and did not have common interests. I could not stand the music he listened to, and he often threatened to break my piano into firewood. He teased me about my perfect grades and called me a "blind nerd" because of my thick glasses. He was far from being a perfect student, because he never aspired to be one. He liked to go out, play tennis and soccer, and was always on the go.

As teenagers, we somehow started caring about each other. Probably a lot of it had to do with being allies when it came to dealing with our parents. We needed each other's support to cover our little lies and to escape from chores and errands. During high school, he became very protective of me, checking up on my friends and expressing his opinions about them, particularly those he did not like. He was actually never a big talker, until he served the one-year obligatory army service. Then it all changed. He wrote long letters about every detail of his army life, which was not particularly interesting to me at all. I had to write long letters back with detailed reports and descriptions of his favorite soccer team's games, rock concerts, and happenings in the city. During that year, we probably "talked" more than we had in all the years before combined. When he came back from the army and started his architectural degree, I helped him with drawings and other projects. He always did everything at the last minute, and I could not believe that somehow he was getting things done. I, on the other hand, liked to plan things ahead and do everything far in advance. But he ended up graduating with honors and became a successful architect.

Now, in his letters from the war, he often tried to be as optimistic as he could, even making jokes. I knew where this seemingly carefree attitude came from. He had to distance himself from things he could not change. He did not want me to worry and he needed to help himself get through this mess.

Zoran, February 1993:
You'll be surprised when (if) you get this, because it will be sent through the post office but will not have postage on it. They don't have stamps, but they

charge you a little—then they give all the mail to the U.N. and it goes out twice a week. Crazy, eh? Welcome to Sarajevo.

I was sitting with some friends the other day and we were talking about what each one of us will do when this is all over. First, I want to take Dad's car and just drive around wherever I want. For hours. Then I want to play some tennis and soccer. And I think I want to eat cheese and sour cream every day for the rest of my life. And how come there wasn't any special French cheese for me in the package you sent via France? That's not how I'd taught you to take care of your only brother! Kidding, of course. The package is out of this world, really.

Guess what happened yesterday: For a little while, we had power and water! At the same time! It was hilarious. Mom was running around like crazy, try-ing to wash things, filling up anything that can possibly hold water. Dad was follow-ing her and asking a million questions, and I turned on the TV to see what was on. And you're not going to believe this: They had a documentary about Los Angeles! I watched the whole thing. You know how weird it is to see lots of cars, freeways, busy life, lights? They said the area of Los Angeles is equivalent to the area of Belgium and that this "supercity" has twelve million people. I thought to myself, "OK, I've got to make it there somehow." Don't have a clue how, though. People get killed trying to run across the airport runway every day, and I am not ready for that.

I also watched the Australian Open; can you imagine? Monica beat Steffi again, which is good. Edberg lost to Courier. That's too bad. But it was great to see some pictures from the outside world. The world is so, so far away from here; even a suburb of Sarajevo is as far away as Mars or Venus, I am telling you, not any closer...But, watch, this chaos will end soon. Can't go on forever.

A few days ago, Chile and Selma came over to tell us that they had been married in Vegas, while they were in the States last year. We had no idea. They said they did it as a joke and that they planned to have a normal wedding here, but...it looks as if that'll be the only wedding they'll have. Man, I told Chile never to trust a woman when she says to do something "not for real" but "as a joke." Can't get much more real than this! She really got him here...Oh, boy. But I have to admit that get-ting married in Vegas sounds pretty darn cool. I congratulated him on that. Selma was freaked out because they were going to her folks next to tell them that Chile is actually her husband, not her boyfriend.

Chile is working to get Selma out of here and to send her to America even-tually. I hope it works for them in the best way possible.

Your letters are great. Keep writing. Life can't be much better than what

you have right now. And don't spoil your time thinking about this place—whatever will be, will be…C'est la vie. Sometimes, I like to imagine that I have already left Sarajevo and that I am traveling to California. I think of that more and more. It's a dream, but still it's nice to get out of here even in a dream. I miss you a lot and I hope we'll talk soon. Now go play some tennis (for me, too) and enjoy!

What Zoran was referring to when he wrote about running across the airfield was actually the only way to escape from occupied Sarajevo. Unless one had connections with international peace-keeping forces or other agencies that had the privileges of entering and exiting the city on cargo planes, the trip across the runway meant either death or a near-death experience.

Sarajevo's airport was modern, renovated only nine years ago, when the city hosted the XIV Winter Olympic Games. It was in the west of the city, in the foothills of gorgeous mountains, which I had always admired when I was flying in and out of Sarajevo. The last time I had seen them was when Djeno and I left for America on our honeymoon. I remember how, after we took off, I turned back to get one more glimpse of the city. The mountains looked stunning. Lit by gentle afternoon sunlight, their dense foliage was displayed in hundreds of different shades of autumn, from intense, bright yellow to red and brown, from deep, dark green to fading blue far away. Light white clouds covered the high peaks, like puffy cotton balls floating in the heights. In the distance, city lights started to show as day was turned into a pleasant night. Down below, suburban houses became little boxes and roads turned into thin, curvy lines. I remembered what one of our friends said as we were leaving:

"Guys, be careful not to fall in love with California! You've got to come back here!"

Now the heavily damaged airport was between the besieged city and the aggressors' positions in the mountains. The United Nations Protection Force controlled air traffic and used the airport to receive humanitarian aid for the city. High-rise fencing was densely spread around the building, and sand bags were piled everywhere. At the entrance, instead of excited travelers carrying their luggage, armed soldiers were standing in their uniforms with serious faces and guns pointed at anything that moved. The murmur of airport crowds was replaced by eerie silence, interrupted only by the brisk sound of bullets and the thuds of shells exploding in the distance.

When I heard about the runway escapes, it reminded me of documentary movies about medieval fortresses, surrounded so the only way out was to swim over water or run across a vast field where the enemy could see you from all sides. In this case, there was no water around, but I bet if there had been, there would have been people trying to swim across.

But this was not a history movie.

Every night a smaller or bigger group of people would gather close to the airport to try their escape.[7] Most would be turned away at various checkpoints, only to return and try another night. Of those who tried, few would make it across to freedom, and the rest would be killed seconds before it. The runway was about 800 yards wide, which might not seem like much. But it was running through sniper fire, mines, and wired bombs—that was the problem.

I wondered what these people must have felt, first when they made their decision to do it and, second, when they actually did it. What state of mind were they in? Did they consider their lives worthless? It was almost as if they were committing suicide, running into death.

I remembered what Chile said in his first letter: "Thank God you will never know."

My mom, March 1993:

I knew you were thinking of me on my birthday yesterday. I wanted to be happy and think of all the wonderful birthdays I had in the past, but those memories, although beautiful, did not bring me much consolation. I cried most of the day, I have to admit.

When I hear your voice for a second, I can hear it for the rest of the day, even if it's only one word. Alija and I talk for hours about our one-minute conversation with you. It's amazing how much information we can extract from your one sentence, the tone of your voice. Did you sound too happy (so we think something's wrong) or too sad? (Why?) Did you just wake up, or are you too tired?...It's endless.

It's still very cold in Sarajevo but much better than in the last couple of months. The worst of the winter is over. This morning it was even sunny for a little bit. The snow is melting. If you asked me how we managed to go through the coldest season, I don't really know how I could answer. We took it day by day, I guess, never talked or thought about tomorrow. There was only today, and there was only one goal in mind: to survive today. For months, I slept in your ski suit under a few down covers and was still cold. In the mornings, before we made a fire, the temperature

in the house was the same as outside. Icicles formed on both inside and outside the plastic sheets we spread across the broken windows. We built fires from anything we could find, including old shoes, purses, luggage, anything that would burn. I am sorry we had to do it, but we had to have heat or else we would have frozen to death or starved. They said on the radio that each resident of Sarajevo is allotted twenty-six ounces of food daily. There were many, many days when we didn't get anything. They also said that 40,000 people are moderately to severely malnourished. I lost a lot of weight. So did Alija and Zoran, but nothing drastic—maybe about twenty-five to thirty pounds each of us. Compared to others, we are doing fine. Zoran said the other day that this diet has many advantages, too—we have lost all of the weight we had been trying to lose for years, and nobody has high cholesterol anymore.

To give you an idea of what we get in this so-called humanitarian relief: Some time ago, we got about two pounds of black beans. I swear those beans were decades old. I don't know where they came from, but it was "special" aid for retired citizens—one pound per person. We had to wait in line for them. I cooked them for hours, but they were still hard and tasted so sour that nobody could eat them. I didn't want to throw them out. I was so upset that I had used so much fire material to cook them that I decided to put them inside the stove and try to burn them as fuel. And it worked. I made bread. They burned for a couple of hours.

Our neighbor, who was also blessed with one pound of beans, decided to grind them into fine powder and make "coffee." She said it was a little sour, but at least the color was appropriate.

Many other things we get are pretty bad, too. The other day we got five ounces of lentils per person, but those were everything but lentils. A mixture of some crumbs, grain particles, black rice, other little seeds, and pieces of I don't know what. I spent the whole afternoon cleaning them, grain by grain, crumb by crumb, and got one, only one, handful of useable lentils. I made a couple of dinners with that.

Along with lentils, we got some cookies (!), but let me tell you—they were made in 1964! Zoran said how those were not as old as him and he still considers himself young. Therefore, we should try them. And we did. We ate them.

You asked what dishes I cook with the few ingredients I have. Well, it is science. Ask Alija or Zoran—they swear my dishes taste different and that the different names I have for them are appropriate. When I cook, I feel some sort of "normalcy." It's a therapy for me. Satka was here the other day when I was making

pita.[8] She said I was so focused on spreading my dough and figuring out what filling to make that my face reminded her of the peaceful times, because it was so relaxed and "normal."

Here are some of my recipes:

Marzipan

7 small cups of sugar, 2 small cups of water, and 1 small cup of oil

Mix it all up and boil. Add bread crumbs and, if you have, a little bit of any type of nuts. Mix it again and add 2 tsp of cocoa powder. Spread it in a dish and sprinkle with sugar.

Gnocchi

16 oz of water, 3 tsp of oil, salt, and ½ tsp of baking soda, 1 egg (optional)—what "optional" means is, if you have an egg, put it in for sure. If you don't have it, it's optional!

Mix it and boil. Then add one pound of flour. Form a "sausage" from this dough, cut into chunks, and put into sauce (canned beef is the best). Cook 7-8 minutes.

Bread Cake (This was a special treat for New Year's Eve)

Stale bread, sugar syrup with a bit of cinnamon

Cocoa powder, raisins, nuts (all optional)

Grind bread pieces. Boil sugar and water; add cinnamon. Form a cake. Add a bit of rum (also optional). Sprinkle with sugar.

Rice Compote

9 cups of water, 2 tsp of cinnamon, 2 cups of sugar, 1 cup of rice, 1 handful of raisins (optional)

Cook well and cool.

Sour Cream

Put 3 tsp of flour into ½ liter of water. Bring to boil. When cold, add 1 small cup of oil, 1 tsp of vinegar, 4 tsp of milk powder, and a little bit of salt. Mix well and let stay for twenty-four hours.

I am not sure I should have written you all of this, especially in my "birth-day" letter. I am sure this will make you sad—but it is what it is. I know you will

hear many more war stories anyway, some of which will upset you a great deal. But that is our reality and we have to find a way to go through it courageously. You, too, have to be brave and determined to think positive.

I hear myself saying "Thank God" so many times, like I never did before, as you know. You might wonder what there is to be thankful for in this situation. A lot. I am not saying it's easy to live here, surrounded on all sides and being bombed every single day, but we are super lucky to be in Sarajevo. It may sound cynical, but trust me, it's a valid point. When I see how people die of hunger and the bitter cold in smaller towns and villages across the country or, even worse, when I see people taken away from their homes, what else can we do but give thanks for our home, this little stove, and the bread we have?

On April 6, 1993, the first anniversary of the Sarajevo siege, Djeno and I headed to the Los Angeles airport. As we were driving, I wondered if the reunion about to take place was merely a product of our imagination, rather than a fact: Selma and Chile had managed to get out of Sarajevo and were on their way to us. To make it even stranger, if that were possible, Chile was coming for only a few weeks. After that, he was going back to Sarajevo to finish a documentary.

The story of their escape from occupied Sarajevo to America was so fantastic that, until I saw their pale faces and skinny bodies walking toward us, I could have sworn we had it all wrong: Chile's two-day-long road journey through blockades and checkpoints; Selma's flight out of Sarajevo on a cargo plane with a fake ID, and her flying right back to Sarajevo because her plane ended up in a different city from where she and Chile were supposed to meet; their reunion in Croatia and their visit to the U.S. embassy to seek visas. None of it resembled anything close to reality under the circumstances.

But here they were. In front of us stood two people who had survived it all, who had seen it all with their own eyes. In front of us stood two living witnesses of Sarajevo's quagmire.

We did not laugh and make jokes and we did not scream and yell, as would normally have been the case with us. We just hugged, cried, and whispered the same couple of sentences many times:

"Thank God, you are alive…Thank God you made it…"

We stood for a long time, looking at our friends in disbelief, as though we were not sure they were truly there, in front of us, alive—the same people, the same Chile and Selma we once knew in another life, now so distant in time and place. It hardly felt like more than a dream.

"Here, this is from your mom," Selma said, handing me a small package when she unpacked their only bag. "She said she had it ready last November for your birthday but didn't have a chance to send it. I think you'll like it."

A gift from Mom for my birthday? In the middle of the war? I slowly removed the plastic covering and a piece of thin, white tissue paper. I noticed the tape on the wrapping was equally measured and carefully placed on all sides. I smiled—so like my mom.

When I saw the gift, my eyes opened in awe. It was the most beautiful hand-knitted blouse I had ever seen. It was made of pure white, very thin silk thread, with amazingly intricate braided patterns all over it, flawlessly done, down to the tiniest motif and detail. To me, it looked like a piece of art rather than an item of clothing. I looked at it for some time, speechless. My eyes filled with tears and I took the blouse and covered my face with it. It smelled like Mom—like her clothes, her hair. I closed my eyes and in a flash the vision of her came to me, real and precise. Too real. I could see her in the room; I could hear her gentle voice. I *knew* she was not there—I knew, but I still felt her there. And I was torn between wanting this feeling to last as long as possible and wanting it to end as soon as possible, for it became too strong to bear. It hurt.

I started sobbing hard and ran out of the room to be alone. I imagined a dark, cold room with only silence in it and my mom sitting in the corner with her work, lit by a weak stream of light coming from a small jar in which a shoe-lace was slowly burning. I thought of how many long winter nights my dear mom had spent making this gift, how often she thought of me. And I thought how perfect it was—because it was made of her love and by her hands.

Selma and Chile told us a million stories about their life in the war and answered a trillion questions we posed. They taught us what different bombs and weapons were called and how each explodes; which one is more devastating than the other because of the shrapnel that bursts and spreads out far; which one is the hardest to hear when it approaches. They told us snipers could see you from a hill above the city, not just from the tenth story of a building opposite you. They could not believe how "uneducated" we were and what stupid questions we were asking. And until now, we had thought we knew everything about the Bosnian war. It turned out we knew nothing. What we saw on TV and read in the paper was just a glimpse of the real torment—carefully edited and adjusted pieces of news and strategically written articles. It was quite another thing to hear it from people who had been in the middle of it, whose stories were harsh truths, raw and unedited.

"Why are you walking funny like that?" I asked Selma when we went on our first walk around town. She was trying to walk really close to the inside of the sidewalk, almost touching the buildings. Her eyes were restless, quickly moving from object to object, scanning the surroundings.

"Oh, it's nothing." She took a deep breath and continued to walk normally, but after few more minutes, she veered closer to the buildings again.

"What's the matter?" I asked again. "Are you all right?"

"Yeah, yeah," she smiled. "Don't worry about it. It's automatic. You know, survival technique. I keep forgetting there are no dangers up in these mountains here. When we had to get out of the house in the war, we'd always walk very close to the buildings or any other 'covers.' That's stupid, because you couldn't really hide from a bomb behind a garbage container, but it's instinctive. That's where it comes from. I need to get that out of my mind."

It was easy to say and impossible to do, because fearing for your life was not something you could simply forget in a few weeks' time.

A few days later, we took our friends to the shopping mall. We were strolling around, looking at things, and talking. A boy with a balloon stood close by. As we were passing by, his balloon popped. Djeno and I looked at each other and twitched a little, but our friends suddenly disappeared! Where did they go in a split second? Then we saw Selma and Chile lying flat on the floor, underneath racks of clothes. The kid looked at them at a complete loss—why would they be scared of a popped balloon? He felt proud. Women who were working in the store turned their heads away and giggled. *How embarrassing,* they must have thought.

"That was a good maneuver," Chile told his wife when they got out of their shelter. "You were very quick. Good job. Respect."

And then he turned to the puzzled kid and said:

"We were just checking out the jeans, you know. Some good jeans they have there—extra-long sizes, too."

"Did I ever tell you how Sanela got out?" Selma asked me one day.

"No, you never did."

"Well, you know where she lived and what happened with that whole neighborhood."

"Yeah, I know," I nodded. At least, I knew some of it. It was within occupied territory and Sanela's family had a "wrong" last name.

"It was too dangerous for her to stay there, but there was absolutely no way to get out. But she got lucky. She was friends with a neighbor who had connections. He put her in the trunk of his car."

"What?" I shook my head in disbelief. "In the trunk? How?"

"You know how petite she is. She fit in the trunk and the guy put some blankets over her and some empty water containers to…camouflage her, I guess." Selma half-smiled. It was ridiculous to think you can hide a human body in the trunk of a small car, no matter how petite the body. "He drove her through all the checkpoints and across front lines, all the way through eastern Bosnia. Can you imagine what would've happened had they found her? If any of those monsters had gotten the idea of looking in the trunk? We wouldn't even have known what happened to her—she'd be gone without a trace."

Selma paused. She was not sure if she should go on. I already had chills all over my body.

"She said she didn't really want to leave her family behind, although her father really wanted her to go. But one day when she saw human ears attached to a belt of one of the maniacs as a souvenir…she agreed to try."

I wanted to scream, but Selma was so composed and collected, I thought I had better keep quiet. If either of us had any right to express rage or frustration, it would be her. I had to ask her:

"Selma, you know what I don't get? How can you be saying all this and still be so calm about it? You're talking as if it's an everyday, normal story."

"What could I do? What could anyone do about anything in Sarajevo? You get used to it."

"How? Seems impossible to me. I think I would lose my mind long before I could get used to such things."

"No, you wouldn't. Well, actually, maybe at the beginning of the war, yes—it was a different story. The first shock of it and all that. Many people couldn't take it. But after some time, it all becomes 'normal.' It becomes your life. You can't change it. It just depends on how high or low your threshold is. Some people took longer; some adapted sooner. The sooner, the better. You do get used to living like an animal; trust me, you do. You get used to being starved and cold, to standing in line for water for hours, waiting for bombs to fall from the sky. You even get used to seeing bodies and wounds so bad it would probably make you vomit right now if I told you. I remember how insanely scared I was when I had to venture out of the basement for the first time. Later, it became routine. I'd put on nice, clean clothes, because first of all, we still wanted to look nice, and second, you don't want to be wearing something dirty if you get killed."

It took me a lot of time to absorb all this. It took me years. In fact, I cannot say for certain I have sorted it out completely to this day. But back then,

one thing did settle very certainly. I knew our life in Sarajevo, as we once knew and loved it, was gone. We were truly the new Lost Generation. Lost in time, in space, lost in our own identity. When this war ended, whoever survived would live God knows where and how, but probably not in Sarajevo. I told myself then, the sooner I get used to these thoughts, the better for me. Still, they kept me awake at night, and I admired Selma and Chile for still being normal. Or, at least for making it seem that way.

A few weeks flew by and it was time for Chile to leave. He was flying on a U.N. plane into Sarajevo and could take only one bag with him. We had four sets of parents who needed just about everything, and we had to fit it all in under forty pounds. Plus, there was Chile's cat that would not eat rice or pasta and was dying. Chile's mother begged him to bring cat food.

We deliberated for days what would be the best things to send, how to pack it, where we could buy the lightest emergency radios, most concentrated spices and extracts, and whether or not we would risk it all by increasing the weight of our packages. Most likely, nobody was going to weigh the bag, so we felt we could pack more than forty pounds. But, if by chance they weighed it, we risked confiscation and our parents would not have anything. It was too big a risk and we agreed to obey the limit.

Then, the shopping. We first bought the absolute "musts": radios, batteries, long-lasting candles, essential vitamins, and medicine. Then we went to a sports store and bought a whole shelf of dry camping food: milk, eggs, dried fruit, vegetable powder, and spices.

"You people must be going on a looooong camping trip," said the cashier. "You've really stocked up!"

"Trust me, buddy," Chile told him. "You don't want to know what sort of wilderness I am going to."

We repacked everything in small plastic bags to save on space and weight. Every bag was marked with its content, carefully folded and pressed to let the air out, then stacked together to form a package. We weighed the bag, and it was perfect—almost forty pounds. Then we emptied boxes of cat food into the bag. Each corner and space was filled. A job well done.

My mom, May 1993:

 Oh, what a day it was today! Chile showed up at the door in his bullet-proof vest to deliver the wonderful things you sent. I am so touched by your deep concern for us and your constant efforts to make our lives easier. It means a lot to us as parents. You'll understand one day.

 When we were reading your letters, some neighbors came over. We were so excited to read them, to look at the pictures, that for a moment, it seemed as if there was no war. It was like a party from the good old times in our house. When everyone left, I sat down by myself and went through everything again and again. I must have gone through the stack of your pictures at least ten times. Both of you look great. It's been more than a year since I saw you. Of course, you haven't changed a bit. We have. Chile said that you wanted him to take pictures of us and bring them to you next time he travels. I am not so sure it is a good idea. Be prepared.

 Today I made a wonderful pita with the egg powder you sent. Thank you so much for all the spices, too. Zoran already had some ketchup with pasta today. It makes a big difference if you have something to put on rice or pasta. It tastes completely different. I love dried onions and garlic. With a little bit of imagination (and we don't lack that), you can make wonders with them. Paprika is great too, because just a dash gives color to our otherwise white food. I still haven't figured out what all the other little bags are, but I am sure we'll love it all.

 I have made a little garden on the balcony. I took out big drawers from the dresser, filled them with soil from the park behind the building, and will try to grow onions, carrots, and parsley in them. I also have bell pepper and tomato seeds. These will (hopefully) be our first tomatoes in more than a year. We generally never talk about wonderful food, because it makes our food taste worse than it is. But the idea of having our own vegetables is a frequent topic of conversation.

 Thank you for the money, too. You have no idea how I feel. I am glad that you did it, because I think that's what you wanted to do, but I feel awful knowing how hard it is for you to put money aside. I would much rather you spend it on yourselves. But, I know it means a lot to you.

 You asked me how we manage to stay sane. I am not sure we will ever be quite normal again, but I know we are different from the barbarians on the hills

around us. They have been taught to hate, and they can go back 500 years and look for reasons for their behavior today. We are not like that. We will still live together one day when this is over. We keep in mind that this, too, will pass, and time will heal many of our wounds. We will, however, NEVER be able to forget the injustice and our feelings of degradation and humiliation.

I also never think about anything "material" anymore; it is irrelevant. I just pray for us to survive and to stay sane. That's all that matters. Now I realize how silly we were before to spend so much money on clothes, furnishings, luxury things, cars...That is so trivial.

My only big wish is for Zoran to leave Sarajevo and one day join you, so that you have one another. After that, I don't care what happens.

Congratulations on your school and all those good grades! I knew you would do well. And please, please, always take care of Margaret and Ruth. You must never forget how they helped you and how their love and care shaped your life for the better. Please give them my best regards. I would like to do something to thank them, but apart from my deepest gratitude, there's nothing else I can do.

My dad, May 1993:

So, Dzaja already told you a lot about the wonderful day we had reading your letters and seeing all of the beautiful photos you sent. I picked one of you and Djeno and put it right in front of this paper, so I can look at you all the time. The flowers in the picture are so unreal; where was this taken? It looks like heaven.

Our new radio is out of this world. (I am thinking you are laughing now... understandable). But I can tell you this: The feeling of isolation is one of the worst feelings I have ever experienced (and I am not that young, so there have been quite a number of them). The isolation we feel here, in our own "prison"—weeks and months in darkness and silence—is, to me, pretty close to being in an isolation cell in a real prison. No wonder people have lost their minds in this city—particularly people who live by themselves.

Radio is our only connection, our only link to the world, our only source of information as to what's happening to us, our only source of entertainment—it is the single most important and vital thing for our survival, ranking way up there with water and bread. And now, thanks to you, we don't have to worry about our radio dying if we don't have batteries. We don't have to be careful about the amount of time we listen to it. And we don't have to sit in silence for two days while it's being charged from a car battery. I am telling you, our new radio is out of this world.

Your letters are exactly what I had been longing for. Full of detail, descriptive, reminding me of the stories from "One Thousand and One Nights." I can almost read them as a book. I have read pretty much everything we have at home, including history, politics, cookbooks, almanacs, and whatever else I could find, plus many books from the neighbors. I am also following all the news, as you can imagine.

I really hope this new conference on Bosnia will bring some changes. I discussed it with many people and everybody shares the same opinion. Europeans have proven to be no help at all. We all believe the Americans are the only ones who could do something to stop this bloodshed. On the other hand, we had high hopes before, too, but they all fell apart like little paper boats on the sea. I think this time something has to happen, because they made firm promises to end the siege and stop the bombardments. Those two things are, of course, the most important for us. Then they can talk about borders, maps, and whatever else they choose.

I wish we had more information and news from the outside world. Does the world talk about us? Are they considering options as to what can be done? Do they talk about military intervention anymore? You probably know much more about what's happening in and around Bosnia than we do. Another big problem for us here is that we hear contradictory information in one single day, good and bad news, and can't tell what's true or false.

I am also thinking you should not send packages anymore. We have not received so many, and the ones we did are half-stolen. We've heard the ones you sent through the Adventist church have arrived but are waiting for the U.N. escort to come into the city. I seriously doubt we will ever get them. They will probably end up, like most of the others, in the hands of criminals and will eventually be offered to us at the market.

A few days ago, I visited Djeno's parents. They are fine. Asim is much better after his stroke and is home now, recovering well. On my way there, I almost fell into a big puddle, and my pants were soaked when I arrived. Mina gave me an old pair of Djeno's jeans and I can tell you they fit me really well. See, I am really slim, like some twenty-year-old, and also wearing modern clothes!

I can see from your stories that, although you worry too much and are so drawn into this war and everything around it, you still manage to compose yourself and lead a good life (or so it seems to me). I think it's wonderful, and you should always strive to keep it that way. You only have one life, and you cannot let anyone destroy it—you have to learn to defy those who try. I know it's not easy, but even if

you sit and cry over us every day and night, it is not going to help. You have every right to be happy and you have to let yourself enjoy. Life is short and really, really fragile.

You will have to forgive my lecturing, but we are still your parents, and you are still our baby, no matter how old you are. You are our greatest happiness and the most precious thing we have—so I reserve my right to be your annoying old father.

I was glad my letters gave an impression of how good my life had become. That was exactly what I wanted to accomplish. It seemed to be working. But was there any truth in it? Was I happy here, or at least happier than a year ago? I was not sure I could answer this question in all honesty, even if I had to answer only to myself. There were times when I thought the misery of the whole world was resting on my shoulders and I wished I had never left Sarajevo. At other times, there was so much rage in my heart that I did not think there was room left in it for anything else. And I was glad I was here, far away from it all. Then again, only a quick thought—a familiar memory, a mental image of a statue in the street where Djeno and I used to meet, the song we listened to in our favorite pub, the smell of roasted chestnuts in wintertime—would bring back all my love for that ravaged place I still called home. And I would be miserable again, questioning myself, wondering when, or if, I would ever see it again. If I did, who would be there? Would it still be my home?

However, amidst all the confusion, I had to admit that I looked fondly on certain moments of my life here. I considered that a big improvement from few months ago. There were even whole days when everything felt like a normal life—getting up, going to work, chatting with colleagues on a lunch break, meeting my study group at school, driving back late at night wishing to arrive home quickly—without thinking once about Sarajevo. But how could I even do that? How could I laugh and enjoy lunch in the sun? How could I *not* think about the war when I knew people in Sarajevo were being bombed and shot at that very moment? How could I go to bed and rest without trying to call to see if my parents had lived through the day?

Figuring out any kind of balance here, it seemed to me, was equivalent to solving a difficult set of differential equations. And usually, those come with too many unknowns, too few constants, and possibly no solution at all.

11

A letter from Amila, May 1993:
I will start working for the International Rescue Committee tomorrow. I am so scared. I am not confident that I can speak proper Bosnian anymore, let alone English. I don't know if the Americans will like me; I don't know how to behave or what to say. My self-esteem is low these days. On the other hand, this is an excellent opportunity for me to earn some money. They are paying $20 per day, which is $20 I need badly. If I stay on the job for two weeks, it'll be $300—a fortune. I am looking forward to spending time in the office, doing things other than cooking, cleaning, and dealing with the children, as it will take my mind off things I shouldn't be thinking about. I will benefit from that. However, my big concern is child care for Adi and Dino while I am at work. I will be giving half of my salary to my hosts' daughter to watch them, but I am still worried that it might not work because they are so used to me being there. But there is nothing I can do about it right now; I'll just have to wait and see how it goes. I know this girl will appreciate some extra money, so I hope it all works out.

Humanitarian aid for refugees has basically come to nothing. A month ago, we received three pounds of pasta, three small cans of fish, laundry detergent, six pounds of potatoes, six pounds of flour, and a gallon of milk. That was supposed to last forty days. Luckily, I still have some money and I know I can count on you two as well, but I would much, much rather try to earn money myself. I am sure you understand. When Chile was here before their trip, he gave me $100. I truly didn't want to take it and felt bad about it. But he just slipped the money in my purse and said: "This is not for you. Get something for the kids."

...I am continuing a couple of weeks later. You will not believe what happened today at work! You will die when you hear this! The United States has officially opened its Refugee Resettlement Program for Bosnians and we are eligible for it—in fact, we were the first refugees to register for it! Do you know what this means? If everything goes well with immigration interviews, we might be on the plane to the States as early as this summer! My head is spinning and I can't stop thinking about it at all. I still haven't told Adi and Dino—I'll wait until I know for sure. I thought I'd wait to tell you later, too, but I couldn't keep it a secret.

I am afraid to hope too much, but everybody is telling me we have a very good chance of going. Our current situation meets all the requirements—we are registered refugees, we have no financial or any other support from anybody in Croatia, and we have immediate family members in the States. Oh, how fantastic that would be…I can't tell you how sick and tired I am of being a refugee. And I have no hopes of returning to Sarajevo any time soon.

Just the thought of having a small place somewhere in the world that I can call mine brings me to tears. This nightmare has been going on for too long.

Hopefully, by the time you receive this letter, I will know more.

I have been working for two weeks now, twelve-hour shifts daily. I am very tired, but I love every minute of it. I helped set up the new office here. The woman in charge is the one who managed the food distribution to refugees. I really like her, and I think she's become fond of me, too. My job is to interpret interviews, of course, but also to do some marketing for the agency. I distributed flyers to refugee camps so people can learn about the program and come here to apply.

Now I have to tell you another thing that is keeping me awake at night. I am expecting Jasko to come soon. I hope it works out. It is difficult, risky, dangerous, but we have to try it. I know the people who are helping me will do anything in their power to assure his safe trip out of Sarajevo, but you never know what problems might come up. Plus, the shelling has intensified—if it continues, it will be a question. If this all works out with Jasko, I was promised that the next person they would try to smuggle out would be Zoran. I truly hope it will be the case. Now wish me luck and think of us. Maybe in a few months, we will be far away from here and will begin to live a normal life again.

It was July 27, 1993.

We turned the television to CNN.

"…And here with us tonight are the first Bosnian refugees who arrived in the United States only a few hours ago," Frank Sesno announced as he made a brief introduction to the program. "These three families will soon be reunited with their relatives in this country."

Then, the cameras moved around the studio, and there she was. For the first time in over a year, Djeno saw his sister, on American national television. Amila was dressed in simple gray pants and a white shirt. She had lost a lot of weight and wore hardly any makeup, but as always she looked dignified and very pretty. She spoke perfect English and I thought to myself, *What an irony, what a game of fate.* A lawyer, she handled herself professionally and spoke calmly with confidence in front of millions of viewers, yet she is now a refugee with nothing but a bag of clothes, at the beginning again, happy to be earning $20 a day in a refugee resettlement office. I remembered a saying I heard from my father many years ago, when Zoran and I were children. He used to say that the only wealth we truly own is what we carry in our minds. Zoran and I thought this was a lame way of guilting us into studying harder. We would rather have owned a new pair of jeans than master a chemistry lesson. But he would tell us that everything in life, except knowledge, could be taken away or be lost, stolen, burned, or spent. What you have in your head will always be yours, and the more you have stored in there, the richer you are. I looked at Amila that day and thought, *How true.*

When asked what she expected of life in America, Amila said:

"All I want is to provide a future for my children, far away from wars and hatred. I want them to grow up in peace and have a normal childhood. That is all I wish for and why I am here. I will try to make that happen."

Then, Adi and Dino were let into the studio. Dino ran straight across the room into Amila's lap, and Adi, older and more aware of his surroundings, slowly walked up and sat next to her. They were handsome blonde boys with big, blue eyes, much more grown up than how we remembered them. They sat there quietly until they saw their faces on the studio screens. Then they started giggling, laughing, and pointing at themselves around the room. I watched them

and thought how lucky it was that they were still little, preoccupied with play and imagination, too young to understand the world around them and their mother's stories.

Only a few weeks after Amila's arrival, the phone woke us in the middle of a hot summer night. Djeno picked it up, half-asleep, listened for a few seconds, hung up, and turned to me:

"You know, it was some woman saying...well, I am not sure...but, yeah, she did say Zoran Basic, that's for sure. But now I am not so sure I heard her right about the rest."

"What? What about Zoran?" I asked, already fully awake and worried.

"Sanja, she said only one sentence, but please, don't trust me too much. I don't know. I *think* she said Zoran Basic is in Croatia and will be contacting us."

I jumped out of bed. It was as if the earth had moved under my feet.

"What do you mean you don't know? Who was she? What else did she say—anything else?" Without waiting for an answer, I grabbed the phone and listened. Nothing but the dial tone.

"No, she didn't say a word more. I don't know who she was. It was an unfamiliar voice. She hung up before I had a chance to say anything. And I couldn't hear her very well. She just said those few words. I couldn't have been mistaken, right? I mean, I didn't make it up; she must have said that."

I sat at the dining room table hoping to collect my thoughts. If it were true, how and when did Zoran leave Sarajevo? Shelling was so intense these days, the worst since the aggression began. Thousands of bombs fell on the city every day. How did he get out of the house, let alone go through the city to the airport? Did he run across the runway? Was he wounded in the bombardments? How did he get to Croatia, if that is really where he was?

Or, is it possible Djeno heard wrong? The name? Or, did the caller maybe say that something had happened to Zoran Basic? Did she reach the wrong number? There might be other Zorans.

So many different scenarios flashed through my head in mere seconds, and all their fragments and scenes came to a big blur at the end. I thought I was losing my mind. Or maybe I dreamed about it?

"Djeno, did we talk about this conversation you just had, or did I just get out of bed and sit here?"

"You didn't dream it. She, whoever she was, did call."

We went over the phone conversation again. We analyzed each word as if it were a thesis, not a sentence. What were the background noises? Did it sound like a call from the post office or through a radio operator? What was her accent; was she a Croat or Bosnian? What was the tone of her voice? Was she in a hurry? Whom did we know in Croatia? Who might have arrived there recently?

Hours passed and we were none the wiser. There was no way to confirm anything or even to disprove anything. There was nothing we could do but wait.

I spent the rest of the night in a strange, empty state, half-dreaming and half-awake. Reality kicked in during waking moments, but as soon as my eyes closed, I imagined my brother was already with me. This went on in endless cycles until dawn—a delicate balance of dream and reality, until they became equal in strength and the line that separated them disappeared.

Morning brought exhaustion and confusion. I got up, got dressed, and went to work, like a robot. By mid-morning, I came to the conclusion that last night should be forgotten. Whoever it was and whatever they said was not real.

I came home for lunch and decided to spend the rest of the day in bed. It was useless to go back to work and try to focus. My body ached. I reached for the phone to call the office. At that moment, it rang.

"Sanja? It's me."

"Zoran? Oh my God, is that you? Where are you? Are you okay? What happened? How did you make it?" I stumbled over furniture as I moved around the room like a caged animal.

"Of course it's me. Geez, hang on a second and I'll tell you," he said, laughing. "You are going too fast! Calm down!"

"Then talk!"

"I would, if you'd let me. I am fine. I am in Croatia. I got out early this morning, on a cargo plane. I got out of Sarajevo, Sanja. I made it out in one piece. It's over. I left." His voice suddenly became quieter. "I'll write you a letter about it when I get to Istanbul."

"Istanbul? Why are you going there?"

"I have to. I'll be there until I figure out what to do. I have friends there who will help me. I can't stay here." He almost whispered the last words.

"You are not hurt, right?"

"No, no, I am fine. I am great, actually."

He was making an effort to sound happy. He probably did not even

know how he was. After seventeen months of war, I did not expect him to be any better.

He said he was eating scrambled eggs and tomatoes with sour cream and cheese, and from the way he was blabbing about it, it was as if he were polishing off some exquisite French gourmet cuisine. He took a shower in the dark, he said. He was so thrilled with the running water that it did not occur to him he also could have switched on the lights.

I never knew until then what a powerful and fast-acting medicine words can be. The emotional and physical burden of the past night, the load on my shoulders, the anxiety, pain, and misery, all of it evaporated like water in the blazing sun with Zoran's stories about the magic of lights, the busy city life, glass windows, the wonderful aroma of food, and the abundance of fresh water. All of a sudden, everything made sense and the whole chaotic symphony of confusion resolved into a perfect harmony. Zoran had made it out alive. He had another chance to live, and I would see him again.

Zoran, 1993:

My first morning in Istanbul. As you "ordered," I am writing. But this is not going to be a long letter. I am just so tired and weak. All I want to do is sleep and eat. It will take me time to get used to living again.

We have a beautiful view from the apartment. It's nice just to sit here and watch the city, the harbor, the boats, everything. Plus, I am having a cold beer, so it's like nirvana.

I don't want to write about the situation in Bosnia. I've had enough of it. All I want to tell you is that Mom and Dad are really okay. They are both very strong, physically and emotionally. You would be surprised. Mom keeps herself busy all the time with cooking, cleaning, knitting, drawing, sewing—you name it. One day she should make an exhibition of the things she has made. It's incredible. She cries sometimes, especially at night, but not that much. Dad listens to the news all the time and it's a miracle he hasn't gone crazy from it. He takes care of the logistics, visits family, and generally tries to organize everything and everybody—you know him. Mom hardly ever leaves the house.

The day I left was strange. I didn't know until the night before that it was happening. I wouldn't have made it if it weren't for an American guy who was helping me, sitting next to me all the time, and telling everybody at check-points throughout the city that I was his interpreter and assistant. I just played the game

and hoped for the best.

> *When we arrived at the airport, it was almost empty. We went through the last checkpoint without any problems, and I was on my way to a big Hercules plane in the middle of the airfield. When I stepped on to the runway, I immediately thought of how many people had been killed here trying to run across. I looked up at the mountains. It was early morning and really foggy. You couldn't see halfway to the top. Really weird and eerie. There were no people around—just the huge aircraft and two soldiers standing next to it. That was all. As I was walking, I swear I was 100 percent sure I was not going to make it. I was certain that those were my last moments. I can't tell you how real it was. You know how sometimes you dream that someone is after you and you want to go faster, but you can't? That was it. My legs were as heavy as lead. I counted my steps as I walked, and with each one, I thought I was getting closer not to the aircraft, but to my own death. I expected a bomb from the mountains, a sniper bullet from across the airfield. I was listening closely to every sound. Nothing happened. Just silence and more silence. I could breathe it in the air.*

> *When I finally climbed into the plane and sat down, it was the strangest feeling ever. I wasn't happy; I wasn't sad. I was just so "empty." When I think about it now, I wonder what it was that prevented me from being ecstatic. My life was saved; I was on my way out of hell. Still, I was just empty. But when the plane took off, and when I looked at the foggy mountains and pictured Mom and Dad down there, in our dark basement, and when I thought of the horrors still ahead of them, it made me feel so bad that I wished I could just feel emptiness again.*

> *…I had to take another "beer break" and just noticed that I can hardly read my own writing. I'll try to do better. Enough of my story about leaving, though. Now I've got to organize myself here. If I ever make it to the States, that would be absolutely awesome. But if I don't, this is not bad either. Far from it. My friends are telling me we could do some work together here. They have already bought a computer (a powerful 486 with a big monitor). It seems that they have some projects in mind. And I am sure it's not going to be a problem. I just have to refresh my AutoCAD. My only problem is the language—I don't know a word of it, but that's okay. If I survived Sarajevo, I can survive everything, everywhere else.*

> *I hope you are happy with this letter—six pages, not bad. Compared to your "novels," it's nothing, but I can't do any better now. I miss you a lot and I hope the day when we see each other again is not that far! Please write. Love you.*

Zoran was right—I was content with his letter and the new dimension

his escape from Sarajevo brought to my world. Our reunion was no longer a dream but a semi-realistic scenario, dependent upon many unknown factors but remotely possible. Dreaming of it, I rediscovered what a wonderful feeling it was to have something to anticipate and really to look forward to it. To feel the excitement, to count months and weeks, to plan for the future. I had forgotten how exhilarating that could be. Now that Zoran was safe and Amila and her family were with us, I was slowly, cautiously, becoming my old self, rationalizing my decisions, being aware of time and the places around me.

City streets no longer seemed so alien. English did not sound as foreign. I became used to studying and reading it. To my astonishment, one day I noticed that my thinking had switched from Bosnian to English for a while, and it did not seem strange. In these brief instants of my inner happiness, I managed to embrace some moments, *live* them. I was not sure if this was generally a matter of getting used to life here, or if I was changing. Whatever it was, I liked it.

On August 19, 1993, the following article about Djeno's cousin Amira Knezevic appeared in the *Times Daily:* [9]

Wednesday was just another day for Amira Knezevic.

She climbed 480 stairs, walked to the river to get water for her garden, picked some tomatoes, yanked a few weeds, carried seven gallons of water up fifteen flights of stairs, and stoked her wood stove a second time. It wasn't even noon yet.

She barely had time to notice it was the 500th day of the siege of Sarajevo.

The day begins for Mira, as she is known, around 7 a.m. when she makes her first foray from her high-rise apartment to the war garden on the other side of the Miljacka River.

Along the way, she passes a corner where a girl was killed by sniper fire a few days ago.

Is she scared?

Her reply is as matter-of-fact as the woman herself—a furrowed brow and a shake of the head.

Before the war, Mira worked in an office and lived an upper middle-class life. She never gardened, except for the flowers she planted at her now-ransacked beach house in Neum, Bosnia's dot on the Adriatic Sea. Now, gardening is her mental and physical sustenance.

Twice a day she descends her apartment stairs, walks ten minutes to the plots on the other side of the river, climbs over a barricade, and crawls down to the Miljacka's edge to collect water in two plastic jugs. Then she gingerly walks the perimeter of others' gardens until she reaches her beets, carrots, corn, squash, and cabbage.

"When I water the garden, I usually bring one cigarette," she said. "I smoke half of the cigarette in the first half of the garden, then I put it out and when I've finished the second half of the garden, I smoke the rest of the cigarette, and my outside work is done for that part of the day."

Once a week, Mira dons her red backpack and grabs a converted children's stroller for the ninety-minute hike to Zuc, a hill north of town, to collect firewood.

She hasn't gone this week because several people have died in shelling on Zuc, scrounging for wood.

After the morning garden routine, Mira and her twenty-five-year-old daughter, Dijana, wait for over an hour in the building's dank basement to collect water, which they then carry up fifteen flights of stairs. That's on good days when there's at least running water to building basements on the western edge of town. Otherwise, they walk to the nearest water collection point, more than a half-mile away.

Then it's on to lunch, the main meal. On Wednesday, Mira whipped up an Italian fish stew, using one can of the mackerel from aid rations, vegetables from her garden, herbs from friends, rice, and macaroni. The only missing ingredient was the white wine, she said with a smile.

The only luxury Mira allows herself is occasional reflection on her summer home in Neum, where family and friends would sit on the balcony under a settling sun and eat prosciutto and drink wine.

She even sees some good that's come out of the siege—her newfound love for gardening and losing forty-four pounds.

The new Mira, with chin-length bobbed hair, bright hazel eyes, and tanned skin, looks nothing like the pictures of old Mira at the beach.

My aunt Satka, August 1993:

Nadira and I were almost killed the other day. I was going from the kitchen into the dining room and Nadira was in the living room when a bomb hit. Incredibly powerful, it blew me off my feet. The detonation was so loud that for a few moments I couldn't hear or see anything. I had no idea where it had hit and, quite honestly, I had no idea if I was even alive. I don't know how I ended up on the other side of the room, but I found myself on the floor close to the bathroom, yelling to Nadira, asking her where she was and if she was alive. But I didn't move. Nadira didn't move either. She yelled back to me from the other side of the living room, yes, she was alive. I glanced over my body to see if I had any wounds, because I was not sure that I could feel any pain—I was completely numb. You'd think that, being in the place where you know they can kill you any second, you'd be better prepared to die. But, no. When that time comes, your mind shuts off. You just never wanna go "there," I guess.

Another odd thing happened. After we confirmed about ten times to each other that we were both alive and okay, we started to laugh, almost hysterically

and uncontrollably. Was it the relief that comes after great fear? It must have been. I crawled into the bathroom and curled up next to the toilet (which smelled awful, by the way), and just stayed there until Nadira found enough courage to get up and come to me. I was shaking for the next couple of hours. Even the rainwater I drank tasted perfectly fine. I probably lost another five pounds or so right then, during those few seconds.

We inspected the damage—pieces of shrapnel were stuck on the dining room wall in several spots, and two windows and the balcony door had been blown out. Not just glass, the whole doorframe had exploded as if it were made of toothpicks. The bomb had hit the apartment below ours. Luckily, nobody had been home.

I am imagining you reading this. You must be pulling your hair trying to make some sense of all this. Well, my dear Sanja, there is no sense or logic in Sarajevo these days. Your rational mind can't understand it, I know. You might be asking, Who are these idiots trying to kill? Why did they send a huge bomb into somebody's (empty) home? What would their accomplishment be if some poor soul was blown to pieces? Or if they had killed me and Nadira? And it doesn't end there: Who profited from killing the twelve people waiting in line for water the other day? Or before that, killing fifteen and injuring eighty when people were at a local soccer game? Who is proud of the "record" set on July 22, when 3,777 bombs fell on us? Many of the inhumane creatures in the hills of Sarajevo are, unfortunately. For the rest of us, this was a day when we were ashamed to be identified as belonging to the same biological species as them. Think about this: If you were to listen to some disturbing sound every thirty seconds (and let that be something as innocent as the alarm on your clock) for one whole day and night, would you go crazy from it? Then add to it a reasonable possibility that every thirty seconds, the sound you hear might be the last thing you'll ever hear in your life. Think about it.

Well, as I said before, there is no logic to it, but there is certainly one goal: to kill Sarajevo's soul. But it is not happening any time soon, I guarantee you that. Not even with two bombs per minute, twenty-four hours a day. The song goes: "If I get killed tonight, don't cry; put a smile on your face—it's not a sin to die for this city."

The famous "Sarajevo soul." Nobody could say exactly what it meant, but there was something about Sarajevo that you could not find anywhere else. Maybe it was a specific sense of humor, jokes on "our own account." Maybe our nonchalant manner. Maybe it was our *carsija's* charm and atmosphere where time came

to a halt whenever you walked through the centuries-old narrow streets filled with the familiar aroma of *cevapi*. Maybe it was our easygoing attitude where problems could be swept away with a midday espresso in a street cafe. Slang expressions that people who were not from the city could not understand, or the everlasting rivalry of the two local soccer teams. Greetings and conversations among friends that consisted of only a few seemingly disconnected words but were perfectly logical and comprehensible to all. You could not be mistaken for a Sarajevan if you did not live there. Even if you learned the tricks. The second you spoke, you would be discovered. You had to possess the unique spirit, the soul only Sarajevo could give you.

After so many months of war and after everything that happened to us, I knew what Sarajevo's soul was all about. It was a theatre performance in the basement of the opera house at minus-five degrees Celsius. A comedy show on the radio full of jokes about enterocolitis[10] epidemics in the city and "technologically advanced, easy-to-install" plastic window sheeting. Sarajevo's soul was the beauty pageant "Miss Occupied Sarajevo," and the song composed to represent Bosnia at the Eurovision competition. The local newspaper, *Oslobodjenje*, printed and distributed daily. Sharing the last bit of bread and water with neighbors without thinking of tomorrow. It was the strength and will power to stop and help the wounded on the street—and risk being shot at because of it. Classrooms in shelters. Piano lessons in music school. Two amputees falling in love in their hospital beds. A wedding dress with a hole made by a sniper bullet. Childbirth in a dark delivery room. The dignity of an old man slowly walking down the Sniper Alley. It was resilience. It was a mindset.

Before departing his U.N. post in Sarajevo, Francis Briquemont wrote a letter published in *Oslobodjenje*: [11]

It is difficult for me to leave Sarajevo. This city is for me the reflection of a Europe I love: multicultural, multiethnic, and multilingual. Your city, much like Brussels, where I live, is a city of crossroads. If Europe loses these crossroads, it will become substantially impoverished. I don't know if what I say is clear to you, but you can't imagine how much I admire you all, Muslim, Serb, or Croat, for your dignity during these trying times, for your fierce spirit of resistance, and for the strong resolution with which you refuse to let die the spirit of Sarajevo. I don't know if you will succeed in your goals. The whole of Europe is stricken these days with a narrow nationalism that is more and more directed against the values of the "other" instead of being based on the peaceful expression of each culture...The names of Sarajevo

and Bosnia-Herzegovina will stay imprinted forever in my memory. I leave part of
my heart in Sarajevo, and part of my European soul. I am not sure if I have been
able to do much for you—being a U.N. soldier can be quite frustrating—but you
have given me the strength to go on defending your cause, wherever I will be in the
future. Goodbye, Sarajevo, and I hope I will see you soon under a regained peace.

Peace did not come. Not to Sarajevo, nor to elsewhere in Bosnia. People were being killed like flies, by the thousands. Human life had become worthless. It seemed to me that the world had completely lost its sense of moral values, humanity, and honesty, for I could not comprehend that this was all happening at the end of the twentieth century and was somehow going unpunished. By the summer of 1993, Bosnia had become the scene of every imaginable form of brutal human abuse and crime against humanity. It was the scene of a bloodbath not seen in Europe since the Nazi Holocaust.

But had we not vowed back then that genocide would never happen again? Do we have the right to close our eyes to such catastrophes—the raging, irrational storms that threaten to sweep over whole nations? Do we not learn what history has taught us?

Obviously, we do not. Or we do not want to. The horrors of this war were broadcast on primetime news on every television station around the globe night after night, month after month, for well over a year. Thousands of Bosnians learned the meaning of "ethnic cleansing" and "systematic rapes" not from history books but from experience. Too many Bosnian children knew the terms "mass slaughter" and "concentration camp" from their lives, not movies like *Schindler's List.*

I have often wondered, *What else needed to happen in Bosnia in order for world leaders to intervene?* Was it not enough that eighty percent of the "civil war" casualties were civilians? That in an era of expanding civil rights movements, advanced democratic societies, in the heart of Europe, seven-year-old girls were being raped in front of their desperate fathers? That whole villages and towns were "cleansed" and burned, wiped from the face of the earth? That people were taken away in freight train cars, beaten, tortured, and slaughtered? Innocent people, forced out of their homes. Not because they had guns and wanted to fight. Because they had the wrong names. Was it not enough?

CNN correspondent Christiane Amanpour, in a *Los Angeles Times* article, July 1993: [12]

It's hard to say what's the worst in Bosnia. Bosnia is the most emotionally wrenching and physically arduous story I've ever covered or been through in my life. You just see terrible stuff all the time. If it's not bodies, it's children bloodied and battered, old men and women injured. In central Bosnia, we saw houses burned and people inside, charred like barbecue, and mosques and churches dynamited.

The war in Bosnia is a war that is being fought against civilians, in the cities, people's houses, not on the battlefield. The United Nations has said that there has never been a war in modern times that has affected so many children. It's horrifying and savage...I keep going back there because I cannot believe this is being allowed to happen.

14

Because of its unique setting in a wide valley surrounded by the glorious range of Dinaric Alps, Sarajevo has always had long, cold winter seasons. There are usually more than 200 days a year on which snow falls. The highest peak, Mount Bjelasnica, often retains snow throughout the summer months.

Winters in Sarajevo used to be nothing short of magical. Wherever you stood in the city, you could see snow-blanketed cliffs, descending to gentler slopes covered with pines and dark greenery. I loved it when it snowed, even in the city, when the streets were covered with that heavy white carpet. I loved it when it was so cold I could hear snow crunching under my feet and when the air was so chilly I thought my own breath might freeze. I loved it when, in the evenings, the *carsija* transformed into a quiet fairytale place—its ancient shops' roofs covered with untouched snow, smoke rising from the old chimneys, and millions of tiny snowflakes dancing under the streetlights. It was a place of serenity and peace.

When we were young, life was grand in wintertime. The ski resorts were only thirty minutes away by city bus, and most of us skied from the time we were kindergarteners. Many families owned cabins in the mountains, so it was easy and safe for us to go. During winter vacations, we hardly ever came down to the city and regularly begged our parents to stay just one more day.

Life up there was simple. We invented our own version of "ski touring," which—slightly modifying its meaning of touring the backcountry on skis— pretty much meant a "tour" of downhill skiing during the day and a "tour" of parties during the night. And it went on in the same pattern for days. Needless to say, we would never get tired of ski touring, and it was always a somewhat sad occasion when we finally had to face reality and return to school in the city.

But it was not just skiing and partying. It was more than that. It was when we grew from teenagers into young adults. People made their best friends there. Had their first fights. Fell in love for the first time in the moonlight, under thousands of twinkling stars. Walked, holding hands for the first time, feeling tingles from the cold on their skin, but a special, innocent warmth underneath it. Kissed for the first time sitting on the floor of a smoke-filled room, to the sound of someone strumming "Hey, Jude" on guitar in the corner.

Winter after winter, *life* was happening for us up there, in the mountains of Sarajevo.

In October 1993, another harsh winter was approaching in the city. It would be the second winter under siege. Mornings were cold and foggy, and daylight gave way to long nights. Nobody talked about the war ending anymore. Sarajevans focused only on how to survive the upcoming months of subfreezing temperatures. Not even the children were looking forward to winter.

Where would they find wood for heating? There were no more trees left in the city parks—all had been cut down during the previous winter. Would they have to carry canisters of water day after day through icy, uphill streets? Where would the food come from, and the money to buy it?

Period of relative tranquility ended abruptly Saturday in Sarajevo, wrote Samir Krilic-Krilla, Djeno's cousin who retired from the special forces and was working for the Associated Press in Sarajevo. *The renewed military activity led to fears of an impending major attack, since artillery often is used to soften up targets for tanks and infantry. The main Kosevo hospital reported seven dead and forty wounded from the shelling, which began before dawn. Lt. Col. Bill Aikman, a spokesman for U.N. troops, described the shelling as the "heaviest in months." The intensity of the barrage—U.N. monitors counted 540 projectiles hitting the city by mid-afternoon—caused the United Nations to cancel flights into the city.* [13]

My dad, November 1993:

We are preparing for another winter that is creeping up on us. We've stocked up on food as much as we could. It's not a lot, but still much better than last year. We also bought some wood, and it's all chopped up and stacked, but we will need to get a lot more. We try not to think about living through another wartime winter, but we must prepare. We know it's coming.

Chile's visit, letters, money, and photos from you made our day. Not day— what am I saying? Made our month! To celebrate the news about Zoran's immigration interview, we made ourselves a feast—real pizza with cheese, sardines from a can, and tomato sauce with oregano. We still don't want to hope too much, but we can't help but dream that one day soon you two will be together again.

I also have to tell you how wonderful the coffee you sent is. We have a special way of making it, too. You take one teaspoon of coffee, two teaspoons of sugar, and one teaspoon of water. You beat it until it's almost white. Then you pour hot

water in, and what you get is the best Italian cappuccino. Add to that the fact that coffee costs $60 per pound, then you can understand how blessed we are.

And before I forget, thank you again for the money and for sending smaller bills, too—you have no idea how hard it is to get change at the market.

The other day we decided to buy three-fourths of a pound of ground lamb meat. Dzaja grew some wonderful peppers in containers outside on the balcony. There were ten small peppers. She stuffed them with a mixture of ground lamb and rice, and it was heavenly. This is the second time since the war began that we bought some meat. Once for Zoran's birthday last year, and now.

So, you can see that we manage (thanks to you for a big part in this). We still have our own place, which is dry and relatively warm. We have clothes and shoes to wear. We still have the strength to carry water. We have our "own" electricity from the car battery. We have received some of the packages you and the others sent. Now imagine this—we even had some mayonnaise! It came in a package from your Belgian friend Katrien. It traveled ten months from Brussels, but we got it! It's been two years since we had mayo. Actually, wait—not true! We had mayo. It is called "Dada's War Mayo" because Dada, our neighbor, invented the recipe. Here is how you make it:

4 tablespoons of flour, 1 tablespoon of milk powder, water.

Cook the above like pudding. Then add to it half a cup of oil, 1 teaspoon of lemon powder, a little bit of mustard (optional) and a little bit of salt. It tastes quite good.

I still go out every day to visit Grandma, despite the fact that I have to cross several very dangerous intersections and walk down one part of Sniper Alley. I believe that if it is meant for me to be killed while walking down the street, I will not be able to escape that. Sooner or later, I have to go out. Therefore, I don't think about it and I just walk. Dzaja has never slept in the basement as many other women from the building do. She thinks that if her fate is to be killed while sleeping, it might as well be in her own bed. After almost two years of going through this, there comes a point when thinking about death becomes normal. You walk out of the door thinking you might not come back, but that thought does not produce panic, as it did before, and is definitely not stopping me from going.

On the other hand, in some ways we act as if we'll be around forever. Your mom starts knitting or painting, thinking and planning how her work will look in the future. I read or write (I sometimes translate articles from French for the newspaper) as though it is completely certain that I will actually finish it. Strange, eh?

If you had a chance to listen to our local radio, you would be simply amazed at all the jokes and funny stories people make up. People still go to work, just to show up there and talk—of course, there is nothing to be done and no money for pay. But we all want one thing and that is to show these worthless crooks in the mountains that we can still live, even under constant bombardment, threats, psychological torture—yes, we are able to laugh, we can be happy. Look at the two of us, for example. Yes, it's hard without you and Zoran here. It will be hard to go through the long winter nights without Zoran's jokes to keep our spirits up. But, deep inside, we are happy we have you, we are happy for your successes and accomplishments, for each new opportunity you get. Nobody can take that away from us. And that is the greatest fulfillment of our life.

My mom, November 1993:

Last Saturday I went to see Satka. This was the second time since the beginning of the war that I gathered enough strength to walk all the way to her house. I left around eleven. It was a quiet morning and not too cold. I wanted to spend the day with her and stay overnight. Now that Nadira left, Satka is very lonely. Also, I wanted to see her before the real winter starts. There is no way I could walk to her house in snow and ice.

It took me about an hour to reach her neighborhood. I walked past several signs—"Beware, sniper!"—but picked the shortest route anyway. By the time I got to the top of the hill, where the bus station is, they started bombing heavily. The ground started to shake and I could hear the whistles flying through air. At the same time, out of nowhere, a terrible cold wind started to blow, and in a minute or so, it began to rain hard. Everybody started running, except me. You know how bad my knees are—I just couldn't run. I stood there, in the middle of the street, all by myself. I thought, "Maybe this is it." I was the only person, exposed to sniper fire from two sides, and so vulnerable standing there with bombs flying around. I thought maybe this would be the end. I thought, "If it is, I will go with dignity." I took a deep breath, looked up, and slowly started walking again toward Satka's house. When I got there, she just stared at me in shock. She didn't expect me to come at all and certainly didn't expect to see me like this, soaking wet and exhausted. On this particular day, Sarajevo was hit with more than a thousand bombs. But, you see, not one of them was meant for me!

The two of us had a wonderful evening together. We just sat there in the dark and talked the whole night about everything, just as we had when we were

little girls. Somehow, though, our conversation always came back to stories about you, Nadira, and Zoran. We were telling each other all the things we hear about your lives in the smallest detail, and even though we worry about you, as mothers always do, we are thrilled you at least have a chance to make something of your lives now. With that conclusion, and with thoughts that you are all now safe, we went to sleep.

The next morning, I heard the news about our weekend house. Sanja, it's gone. Completely. Last night. Who knows—I might have heard the bomb that destroyed it when I was at Satka's. I just didn't know it. It took a direct hit from the hill on the opposite side, the one you could see from the living room window. (Remember how everybody admired the view?) The bomb was a massive one. It went straight through the roof into the living room. The bedrooms above the garage are still partially there, or at least that is how I am imagining it. Neighbors who saw it told us there are a lot of wooden beams lying around, and that we should some-how collect them. We would probably have enough to heat us through the winter. But it is way too dangerous to go there. We asked them to pile the wood up in the garage for now, if the garage is still usable and dry. They are nice people; they'll do it for us. We told them to take some wood for themselves, too.

So, you see, in only one second, some idiot destroyed what we had been building for twenty years. I wonder if the person is now happier knowing what he did. I would want him to know that Alija and I did not even blink when we heard the news. Yes, we are sorry we lost it, but compared to all the other tragedies, human as well as moral, this is nothing.

I loved our house. My mother had designed it years ago. It took almost a decade to build because my parents did it mostly with their own hands, from the beautiful, wooden-beamed ceiling to the unique fireplace, entirely made of antique stove pieces that had belonged to my mother's family for generations. The house was relatively small but had a great floor plan with a two-level dining and living area with big windows and large patio doors, opening up to a terrace covered with gorgeous plants and vines. My mother had planted more than a hundred different types of roses, her favorite flower, around the house, care-fully matching the flowers' colors. Upstairs were two small bedrooms with large French windows overlooking the big wooded area where my father had a built-in barbecue, benches, and tables, all in the shade of huge oaks. The house perfectly blended with the original landscape and the slope of the hill. Over the years, my

mother gave the plans for the house to friends who wanted to build houses like ours. At the end, there were fifteen "Dzaja's houses" around Sarajevo. Now, one was gone.

When I was small, I could not wait to go there with all my cousins and friends. We would play outside for hours, run through orchards and fields, hide in the tall grass, climb trees, pick wild berries, and steal fruit from our neighbors until our cheeks turned bright red and our legs felt shaky. Then we would lie down in the shade under huge trees and look up at the rays of sunshine blazing their way through thick branches and leaves, trying to guess which spots on the ground would light up next.

As a teenager, I dreaded going up there because "there was nothing to do." I preferred seeing my parents go there for the weekend, so Zoran and I could stay home alone. But as the years went by, things changed drastically. Djeno and I spent many weekends there with friends and we discovered the best parties we could throw were the ones up at the weekend house. There were no neighbors close by to complain about the noise. We could have as many people as we wanted and stay as late as we wanted. It was just perfect. Djeno and I had planned to live in it temporarily when we returned from our honeymoon trip until we could find permanent housing in the city.

I tried to imagine what the house, or whatever was left of it, looked like now. Then an inevitable thought came to mind. *What would have happened to us had we stayed there? What would have been our fate? Would we still be around?*

PART III

1994-
1995

It was February 6, 1994. I went to Mrs. Hughes's house to visit. I unlocked the back door and hollered my usual greeting to let her know I was in the house. Normally, she would call my name back and invite me to come into the study. This time, I was met with silence.

I quickly checked the bedroom and walked into the dining room. She was sitting on the edge of a chair, watching the news. She did not greet me with a hug or even a smile. Her face was grim and the wrinkles around her eyes appeared deeper than usual.

"Have you heard?" she asked as she turned off the news. Her hands were shaking.

"What is it, Mrs. Hughes?" I dropped my purse on the floor and sat down on the closest chair.

"The latest BBC report. Where is this open market called 'Mar-ca-le' or something similar?" She stopped and looked at me carefully, searching for an answer on my face. "There was a mass killing there. It's bad, Sanja. You must call tonight."

She went on to say more, but I drifted. I knew my dad went through Markale every day on his way to Grandma's house. The market was one of few places in the neighborhood where they could find food. I felt cold drops of sweat on the back of my neck and the room became darker.

I took the remote from Mrs. Hughes's hand and paused for a moment, trying to prepare myself for what was ahead in the next few minutes. Pictures of Professor Djikic and scenes from the Breadline Massacre raced in front of my eyes. I was ready to see my parents die—but I could not bear the thought of seeing them suffering.

The attack occurred mid-afternoon on a brisk, sunny Saturday when the market was most crowded. It lasted a sole second. A single, 120-millimeter mortar shell, containing five pounds of solid explosive, blasted into a mass of human flesh, bursting with pieces of hot shrapnel, slicing bodies as though they were rag dolls. Initial TV reports were too short or too frantic to follow. Others were edited from close-ups and showed a few frames from a distance: stained wooden market tables and a truck loaded with bodies soaked in blood so badly

that it looked like all the victims wore the same color coats. It was impossible to recognize any faces on the TV screen.

With each hour's news, the number of casualties grew, and by the end of the day the count stood at sixty-eight dead and 206 wounded.

Djeno and I dialed radio operators in shifts, day and night, but did not get through for a whole week. We videotaped news reports and watched them frame by frame. We looked for names of the victims in daily papers and magazines. With each passing day, our hopes that our folks were alive rose higher. Had there been something tragic, we told ourselves, we would have probably *somehow* found out. Bad news usually traveled fast.

Still, when an unfamiliar number called on my fax machine at work, my heart stopped beating and I could not wait for the whole paper to come out. I ripped it in pieces and read. It was a letter from my dad:

We are ALIVE, Djeno's family and us. We were dying to let you know sooner, but we didn't have a chance. I asked a neighbor whose daughter works for the U.N. to fax this to you. I hope I have the right number.

A few people from our street were killed. Among them, your friend Senad's mother. It was instant for her, thank God. Everyone in our building is accounted for.

We missed the whole thing by about half an hour, thanks to Dzaja's aching tooth. We went to the dentist in the morning because she couldn't stand the pain she'd had for a few days. On the way back, we'd planned to go through the market, but Dzaja was already tired from the long walk and we decided to rest. We found a bench close to a small cafe and sat there. A young guy came out and offered us some coffee. We spent fifteen minutes or so there, and then we heard it. We knew it was very close, but we couldn't quite locate it. We left in a hurry, taking side streets and narrow allies, as we were expecting more bombs. As soon as we came home, we heard all about it from our neighbors. A few of them had left to help load the bodies into cars and trucks. There aren't nearly enough ambulances and morgue vehicles for a job this big. Sanja, I pray you never see anything like this in your life, not even in a movie.

I repeatedly told myself it was all right. They could have been there, but they were not. It was over. Still, I was not relieved. Something crucial was missing—that fine thread that connects it all, the ease we feel after great worry is put away and we can unwind and let go, was not there. I stood there, staring at the letter, sifting through my thoughts like a conductor listening to orchestra sections

playing their parts, but not being able to pull it together into a cohesive piece. It was all there in fragments, in front of me, but it did not sound right.

In this strange mindset, I got a phone call from Zoran.

"Remember when I told you I'd be in Pasadena for the World Cup this summer?" he said casually. "You should get me some good tickets for the Rose Bowl."

"Yeah, sure. What's up with you? Do you have anything better to say? Did you find any work?"

He had been in Istanbul a few months already and I was worried for his future there or elsewhere in Europe. Nobody wanted Bosnian refugees.

"No, Sanja—I am coming!" His voice suddenly became excited.

"Coming...where?"

"To Pasadena! Told you I'd be there to watch the World Cup!"

He is crazy, I thought. I started pouring out questions, asking him about his immigration interview, where he was, what was *really* going on, but Zoran was in no mood for explanation. He already had a one-way ticket in his pocket and could not contain himself. He burst into his typical loud laughter that I hadn't heard in years, yelled several "woo-hoos," and proclaimed in his accented English: "This is no joke, ladies and gentlemen—Mr. Basic is coming! America, get ready!"

I fell asleep that night and woke up in the morning sifting through the same thoughts, over and over. *Is it too much to hope for? Am I so lucky to reunite with my brother here, in America, after all that happened? What will be the price I pay for it?*

It was hard to restrain my excitement, but I had to be cautious and protect myself from possible disaster, in case the whole deal did not materialize. I laid out all possible scenarios of failure, and I came up with many, so I could tell myself later it was not realistic to begin with. I could not afford to consider this as certain. Still, in the days leading to his arrival, I was equally as excited as I was sick with anxiety and worry. Sometimes I could not even differentiate between the two. Counting days had never been harder. I would walk up to the kitchen calendar with a pen several times a day, only to discover the date already had been marked multiple times. I remembered how my father claimed that time does not pass equally—years and months seem to pass much faster than weeks and days do, but hours, even minutes, seem to never go by.

My dad, February 1994:

I hope you got our last letter which we sent with an Italian journalist. It's been hard to find couriers for letters lately, and it's been really hard not to hear your voice for more than three months. Last time we talked through radio amateurs was on October 18 of last year.

We were horrified to hear about the big earthquake in Los Angeles. Dzaja couldn't sleep; she cried the whole night. She said she could kill the people who are doing this to us—she wanted so badly to pick up the phone and call you. We know how scared you are of earthquakes and couldn't help but think how horrific it must have been. I wish we knew whether everything is all right.

We got a message from Zoran saying he should be travelling to America sometime soon, but we don't know any details. I am afraid to think about it. I worry about his travels, entering the country and a million other things. If/when you go to the airport to pick him up, please let Djeno drive. I know how anxious you will be. Also, tell Zoran, but not right away when he comes, that Senad's mother was killed.

Life in Sarajevo is pretty much the same. Shelling is somewhat less frequent. However, you have to be on alert all the time, because it's become a specialty of the maniacs in the hills to start shelling just when people think it is safe to walk out. I still take the same route when going to Grandma's, through Markale market—I figured it is really all the same; there are no safe streets. I try to hide from snipers behind U.N. containers at bigger intersections. Where there aren't any, I run.

We now have water every other day for a couple of hours, so I don't have to carry it in canisters anymore. It is huge, especially when streets are icy. We have also had gas lately—not all the time, but enough to heat up the house a little and, of course, to cook. Still, we have bought enough wood to last us until spring. You never know. We have the stove from last year that still functions even though it has a bullet hole in it. We also have a small, homemade "stove" I made from a large can. You can boil water for tea or coffee on it, or warm something up. You'd be impressed with my work, although mine is very simple compared to some others I've seen. One of our friends built a stove from a pressure cooker. He turned it upside down, made a base from wires along with a little "drawer" to collect ash, and the exhaust goes to the balcony out of an old pipe (took out the handle). It stays warm for a long time. It's genius.

Regular power has been completely shut off for well over a year, but now we have what we call "stolen" electricity from our second-floor neighbor. You can use it for only one light bulb or something small, but it's quite enough for reading,

writing, or knitting and is so much better than our homemade "candles." We don't even know where this stolen electricity comes from—must be some "priority" or who knows what—but we don't really care. People do it all over town. It's funny to watch some of the building roofs at night—you can see the silhouettes moving around stealing the cables and spreading them around.

Please try to send us a letter somehow, or at least a message, to let us know you are all right after the earthquake.

16

On February 24, 1994, Zoran landed at Los Angeles International Airport. Oddly, I did not write anything about it in my diary and cannot recall most of that day. I know I was rushing to get everything ready for him and cook his favorite dishes, but other than that, I do not remember much else—riding to the airport, waiting for his flight, what he looked like, not even the moment we hugged each other. It was one of those larger-than-life moments that, after being anticipated for so long, do not feel like reality at the time they happen—as if our brains need more time to process the fact that the event itself has finally occurred and that we do not have to live in anticipation anymore. The big moment was there, happening, but I was not aware of it and did not enjoy it as I had hoped. After a couple of days, the reality of it sank in, but the memory of that day is forever lost.

Zoran's arrival brought something else into my life—I did not feel like a foreigner anymore. With him in America, I felt like I had a safe haven to turn to. What kind of safe haven was Zoran, with no money and no job, at the beginning of a new, uncertain life in a foreign country? He was more of a burden to me, if I looked at it realistically. But my brother was *here*, and those words sounded grand. Reassuring and strong, overpowering everything else, they made me feel safe.

During the first few weeks after his arrival, Zoran appeared to be the same fun, goofy guy he was before the war, the kind of guy who cared more about soccer scores than anything else. He immensely enjoyed the warm California weather and spent many hours chilling by the pool and playing tennis. I marveled at how unconcerned he seemed about his new life here—vastly different than my own beginnings in the United States. Even though he is three years older, I often felt like I was much older than he.

"Come on, I lived in freaking hell for over a year," he explained. "Then I travelled from place to place for another six months and was not welcome anywhere. I had to hide like I'd done something wrong. Now that I've finally come here—this is the end of the road for me. I don't need to think where I'll go next. I don't have to worry when I say in public that I am a Bosnian. So, what's there to be worried about? Money? A job? It's downright ridiculous to worry about that."

However, after a few weeks, he changed. His usual laid-back and casual attitude was suddenly gone. Often, for no apparent reason, he would drift away from a conversation and surround himself with a wall of thoughts impossible to break. He started having nightmares that would leave him drenched in sweat. It was always the same dream: He was back in Sarajevo, and he could not escape.

He started talking about the war all the time, comparing it to his life now. Each sunny day would prompt memories of long nights in darkness in our building's cold basement; a look at neat, flower-lined Pasadena streets would bring up pictures of burned tram cars and bomb craters on the streets of Sarajevo; and each meal started with a story of hunger and struggle to find food in the siege. He ate things that he would never think of eating before the war, even eggplant, and would not let us throw away even the tiniest bite of food. After dinner, he would take a piece of bread and wipe his plate clean. He told us it was how they washed dishes in the war. He was more agitated when I tossed a half-rotten piece of fruit than he was over his stolen car, although he had spent all his savings on it and had owned it for only several weeks.

My mom, March 1994:

Maybe you are wondering why Alija always writes and I don't. It doesn't come as easily for me. There are so many things I want to tell you, it wouldn't fit into ten books, let alone letters. But when I start writing, I can't remember most of it. I live for our phone conversations, because even though they are short, I some-how concentrate enough to ask meaningful questions. And I get answers without having to wait for months. Although, I have to admit, I am very sad afterward.

One thing I can tell you, though, is that I am a new person, now that I know you two are together. I know it is not easy to start all over, and Sanja, you have already gone through a lot of that, but Zorancho, you will have to put a lot of effort and patience to build your life again. It still must all be just a great confusion for you, but I am sure you will get used to your new life very quickly. Compared to Sarajevo, life in a jungle seems like a joke. Don't be reluctant in seizing whatever opportunity you may get to earn some money. One day you will get a job in archi-tecture, I am sure. When you feel it's hard to establish yourselves there, be happy that you have each other, that you can share your problems and dilemmas, and that you can always count on one another if the going gets tough.

When I think about how Alija and I always wanted to provide a good life for you two, I want to scream out of anger at what has become of it. Not only can

we not help you, you have to help us. On the other hand, I am extremely lucky to have both of you and to know that you are not in danger anymore. They said on the news a few days ago that February 22 of this year was the FIRST casualty-free day in the city since the siege began.

Today is International Women's Day. It brought a lot of wonderful memories from the past. The city is much livelier than last year and street vendors are selling fresh flowers again. The winter is almost over, and we have some clear and sunny days. I took a walk down to the cathedral and passed by your music school. I remembered how I used to take you there when you were a little girl and how you loved your piano classes and hated solfeggio. Seems like the whole world has changed since then, but one thing hasn't—you can still hear music every time you walk by the school, only now it's not coming from the open windows upstairs but from the basement and lower floors. Classes are still being held, although I've heard seven students and one teacher have been killed so far while walking to school. The building is badly damaged. The concert hall on the top of the building, where we attended your recitals and exams, took several direct hits through the roof. The grand piano is still there, but it, too, is ruined.

We celebrated my birthday and your reunion with a nice dinner with friends and neighbors. I made soup and "spanakopita" from mushrooms and canned spinach. The cake was an upgraded version of the "bread cake" I made before (which is just stale bread soaked in sugar water with a little bit of cinnamon). This time I had a handful of raisins, some walnuts, margarine, and cocoa powder. It was really good and it looked quite nice, too. We also had some of the wonderful liquid cheese you sent with Chile, and I served it as an appetizer with toasted bread. You had mentioned that once the bottle is open, it had to be eaten fast. Don't worry, we are following the rule! The biggest problem was what we were going to drink. We didn't have any more wine, and we haven't had any other alcohol for the longest time. However, we had a bottle of good old cognac, which we were saving for I don't even know what—maybe a day when Zoran would get married? Well, sorry, Zoran, you had your chance—we opened it and drank it.

Please write whenever you can and whatever you can think of. Even the smallest detail is of great importance to me.

I did write—pages and pages of letters, broken down into chunks, numbered, sorted by series, and sent via various channels to Sarajevo. I repeated important points and events several times, because I knew not all letters would

make it there. My goal was to reassure my parents there was nothing to worry about, and that our lives here, compared to theirs, should not be a subject of concern.

It was rewarding to write about our accomplishments—Djeno's job as an associate engineer, his acceptance into graduate school, Zoran's first job as an architect, my school, our first savings account—but as time went on, it became a difficult task to write. I struggled to admit to myself that I did not live for those moments when I would sit down and write. This realization made me feel incredibly guilty. I believed I'd betrayed my family in some way. I did not think about the war every day. I was not staying up awake all night trying to get through to radio operators. Only a year ago, I could count moments in a month in which I was able to distract myself from the war. But somewhere along the way—I do not know how or when—my own life took over and I started caring for it more than I cared for the news from home. I wanted to graduate in the fall and start my career, find a better job in a large company. For the first time since I got married, I thought I would love to have children.

I often wondered if my parents would be sad knowing the focus of my life had shifted so dramatically from the war in Bosnia, from them, to something else, which might have seemed trivial in comparison. What I did not understand then is that they would have loved the fact that I'd finally started living my own life, because that was what they had always wanted me to do.

One morning, while flipping through the *Los Angeles Times,* I stumbled across an article about life in Sarajevo in a section of the paper where I would least expect to find anything on the Bosnian war: the Food section. The article was titled "Bosnia—Food for Survival" and had a big picture of No-Bake Chocolate War Cake with War Cake Icing. It was served on a nice plate and had mint decoration on the sides. The icing looked like the tastiest chocolate frosting. I read it and smiled. It was almost as if someone had written a story about my mom's birthday cake. Among ads for fancy southern Californian restaurants and Hollywood's celebrity chefs' resumes, there were two pages of recipes from ordinary Bosnian women who managed, with only a few ingredients, to make complete cookbooks and exchange hundreds of recipes: cheese made from rice, mayo with no eggs, meat pate made from beans, all sorts of cakes, savory and sweet pies, soups, and beverages. These recipes were read on the radio, published in the newspaper, or spread around by people waiting in lines for water or humanitarian aid. "Gardens" like my mother's, planted in buckets, wash bins, drawers, and containers of all shapes and sizes, were decorating damaged city balconies and windowsills. Every patch of green area in the city was cultivated. People put their lives in danger for a few pounds of potatoes or cabbage. Our close friend's father was killed by a sniper while weeding his vegetable garden.

My dad, June 1994:

Speaking about being superstitious: This morning, I put on my shirt backward, and Dzaja immediately said it was a good sign—something nice would happen today. She was right! We got your letter, package, pictures, and money. I don't know what I like best! I think the coffee. Or maybe the cheese. The razors are also great. I only had a couple left, and they were rather old and worn out. Now I can finally properly shave.

I am glad you sent us photos of Pasadena. Although I had seen the city before, now it looks even more beautiful...a lot of greenery, palm trees (tall ones, too!), nice homes. Is it called the City of Roses because of the Rose Parade or because it just has roses everywhere? Dzaja would love it there.

Dzaja and I concluded that we have the best children in the world. We don't know if it's our doing or if you were just made that way. We saw with how much love you packed all these things for us. The prices at the market are falling so the money you sent is a whole fortune for us. A pound of sugar is only one dollar (down from ten), oil is two (used to be fifteen), and you can even buy cheese, chicken, and some fruit. Humanitarian aid is better, too. To illustrate, here is what I got for the two of us (for a period of twenty days): four pounds of flour, two cans of beef, one pound of beans, one pound of peas, half a pound of sugar, and half a pound of milk powder. Every two to three months, senior citizens also get three pounds of some kind of cookies (which are very, very stale) and one pound of milk powder (because of which I go there to stand in line). Most of the food now comes into the city through the tunnel—Zoran can tell you what it is, if you don't know.[14]

An unbelievable miracle recently occurred: We had water, gas, and power at the same time for three days straight, which means that after a long, long time (I am ashamed to say how long), we could take a proper bath. We couldn't believe what a good time we were having! Electricity changed our life—we could watch TV: news, local and international, movies, and concerts. Last night we watched a wonderful concert from New York (Tchaikovsky). We also watched our local programs a lot—soccer games, basketball, even kids' programs—and enjoyed in it tremendously.

The city is livelier, too. People are braver and walk around much more. There are more art exhibitions, theater shows, and concerts. We go out to visit friends and relatives. I played cards with my buddies for the first time in over two years—it was awesome! The other day, Dzaja and I went to an art exhibition, and Dzaja saw some of her friends she hadn't seen during the whole war. We have also started going to the dentist. We have a lot of work to do, both of us, but it's a pleasure to be able to do it! Did you ever think that anyone could say visiting a dentist is a pleasure?

Some of the bigger streets are being cleaned from debris, glass, garbage, and other junk. Can you believe they started washing Titova Street? There is also a possibility that the tramcars will start operating soon. That would be a major accomplishment. People are a bit happier, telling a lot more jokes, and that is always a sign of better days to come.

The heavy artillery is being moved from the city outskirts and will soon be under UNPROFOR's control. I said many times before that we don't trust in anything anymore, but we hope this is a beginning of some sort of peace for Bosnia. Sometimes I fear life is becoming sort of "too normal" here. What I mean is that

people are not careful enough. I often see a large group of young people gathered in front of a cafe or somewhere else, but in my opinion, we are still very far from being safe. However, it's impossible to resist going out, to meet people, and to engage in social life again.

I can't even comment on your photos and letters. I can only say that when I read your stories and look at your wonderful pictures, I feel like I am living there and watching your life unfold in front of my eyes. This is remarkable considering how far apart we are and how different the circumstances are here and there. We can see that you keep everything "under control," as Zoran likes to say. I have a feeling he and Djeno are just saying that but that you are the one who keeps things (and the two of them) under control! And I thank you for skiing one run for me—I hope one day we will ski together again.

I bet Zoran must be thrilled that he will be watching the World Cup in Pasadena! It seems like yesterday he was sitting with us here, in a dark room, with a bunch of sweaters and jackets on, without any hopes whatsoever to be anywhere else in the world outside of Sarajevo, let alone in Pasadena, California! And tennis, swimming, driving, all the things he was dreaming about. See how life turns around? This should be a good lesson for all pessimists out there.

We will ask Chile to take some things from here to you—Zoran's diploma and a few little things for you—since we probably won't have another chance to send you a graduation gift. Dzaja wanted to buy you a nice dress, but you can't buy almost any clothes here yet. Some stores are open, but it's mostly necessities. There is one lady who sews beautifully, but that doesn't do us any good, since we have no idea what the fashion trends are and what people wear in the world nowadays.

My mom added:

If you get a chance, watch the benefit concert that was held a few days ago in the ruins of the National Library. I am sure the Americans will broadcast it—we've heard that more than twenty countries already did, many of them live. Zubin Mehta conducted the Sarajevo Philharmonic Orchestra and Cathedral Choir, and Jose Carreras, among others, sang. They performed Mozart's "Requiem." I don't need to explain to you the symbolism of the piece, but I can tell you we were spellbound. The fact that these artists came here, rehearsed in the basement of the opera house, and risked their lives for this performance gave us all chills. There was no audience in the library and the interior looked exactly the same as it did after the library burned down almost two years ago—floor covered with broken bricks,

shattered mosaic glass and ash from the burned books, damaged walls and deco-
rations, half-burnt and charred atrium columns. They only cleaned enough to put
the musicians in the center of the octagon. The concert started with maestro Mehta
walking over debris to his podium, in his tuxedo and shiny shoes, as though he were
walking onto the Metropolitan stage. He said they played for the people of the city
and for orchestra members who lost their lives.

I watched the concert with a heavy heart and teary eyes. I imagined
the sounds escaping through the empty windows of the library, competing with
the sounds of war outside—calm, adagio voices singing "Eternal rest grant unto
them, O Lord," overshadowing the whistle of sniper bullets through the air, alle-
gro strings defeating the persistent gunfire close by and loud timpani trembling
against the roar of exploding bombs.

Why did this music sound strangely different to me this time? I had
heard "Requiem" before, but never had it been so profound, never had it touched
my soul so deeply. It seemed slower than usual, heavier, as if each word of it
stood for one killed citizen and each plea for mercy epitomized a child's prayer
for peace. Each note had its own purpose and relevance and wanted to drag on
a bit longer, to make a statement. Each harmony, so perfect and powerful, was
never meant to leave the atrium of the library but to linger there forever.

"Merciful Lord Jesus, grant them rest. Amen."

The concert ended in silence and the magic disappeared. Sarajevo sur-
rendered to the sounds of war again.

On September 1, 1994, my dad's seventieth birthday, I managed to make a phone call to Sarajevo.

"Dad, happy birthday!"

"Sanyushka, it's you! What a wonderful surprise! How much time do we have?" He was happy, as always, to hear my voice.

"Not much. But listen, I've got a gift for you for your birthday. I think you will like it. I graduated today, Dad. Your baby has a master's degree now."

There was nothing but silence on the other end.

"Dad, are you still there? Hello?"

Silence again. I do not remember any instances in my life when my dad could not come up with anything to say. On the contrary, he was known to have ready and quick answers and comments for everything and everybody. For a moment I thought we were disconnected. Then, I heard a sniffle. Or did I? It was hard to believe my dad was crying and I was witnessing it, for the first time in my life. But when I heard his shaky voice and whispers to my mom, I knew what was happening.

It took my parents a couple of minutes to compose themselves and start asking questions about my thesis, the professors on the committee, how long it was, why I never told them the date—until the disconnected line reminded us that this occasion, like any other, was just an ordinary day at work for radio operators.

My mom, November 1994:

Only God knows how much I miss you. Last night, Alija had a dream about you and I was so jealous. I have never dreamt about you since the day you left, and he has, several times. If I could see you just for a second, even in a dream...

Hearing about your and Zoran's life is what keeps us going and hoping that one day somebody important will somehow figure out that there has been enough suffering in Bosnia. I think we have shown more than enough of it, but it seems more reassurance is needed. Even kids here joke about the U.N. "safe havens" and "human rights" and they know they are as real as the cartoons they read. But the hatred they experienced, even before they experienced their own childhood,

they know is real. They will grow up convinced no one can be trusted and that this world is a cruel place, full of lies and vain promises. I wonder, if the big and powerful governments are not going to intervene here, where would they intervene? What is a determining factor—oil, money, business, political interests? What about the basics—humanity and moral obligation? How will we keep this planet a safe place for the generations to come if those who commit such horrendous crimes walk around unpunished?

Sarajevo is now at almost 1,000 days of siege and has lost one-third of its population. We are past the point of the longest siege in history—Leningrad, which, I believe, was around 830 days long. Honestly, I don't know what else we can offer.

It's already November and it has become quite cold and foggy. It was only two degrees Celsius this morning. We are preparing for yet another winter. We have bought another cubic yard of wood. Although the supply of food is better, we have stocked up on a lot of basic items. The gas is shut off during the day and we only have it for a few hours starting at 11 p.m. As soon as it comes on, I start cooking for the next day. The problem is that they shut off electricity at night, so I have to use candles to maneuver around the kitchen. It is still better than cooking during the day, because I would have to use wood. Zoran knows what this looks like; he can tell you.

Now some family news: Uncle Izo has made it back to Sarajevo. You know he left right before the war started with his daughter and stayed in Italy. Now he decided to return to try to get their house back (refugees from another part of town have lived in it all this time). He came back through the tunnel, which we now call "Sarajevo's Metro." How he made it back is quite a story.

He came to Croatia first and then took a bus to one of the suburbs of Sarajevo. Then he joined a couple of people in a pick-up truck to go over Mount Igman to reach the tunnel. However, as they were driving, they were shot at. He fell from the truck on the road. The truck drove away. His upper lip was bleeding. He said he was so terrified that he couldn't figure out if he should stay there or walk down the hill. Soon a car showed up from nowhere and took him to a nearby village where they found a doctor. He had three pieces of shrapnel in his body—one right above his lip (a very small one), the other in his arm, and the third one in the skin on his neck, missing a major artery by a hair. The forth piece of shrapnel didn't enter his body—it was stopped by his wrist watch!

When they bandaged the wounds, they transported him in a wheelchair through the "Metro" and into the hospital. He stayed there for a few days and is now

doing quite well. If you are in touch with your cousins in Italy, don't even think of mentioning this. They have no idea.

The other day when Satka was here, we talked about what each one of us would want to do the most right now if we were free. Satka said she would love to leave the city, go to the mountains, find a pretty meadow, and lie there for hours enjoying her freedom. Alija wants to drive in his old car far away from here, maybe to Austria or Italy, and stop by little restaurants and pizzerias to have some good food and wine—white or red, doesn't matter. And I want to fill the bathtub to the top and stay there for three days, not thinking about anything at all. After that, I want to have a whole pack of some good cigarettes.

Unfortunately, these are only our dreams. The reality is that we are still inmates in a prison called Sarajevo. I recently heard on the radio what one writer said about this siege: "It is as if God created a model of hell and put it down in Sarajevo to test." An interesting observation, but it seems like we are the only ones who have heard it.

But the message was slowly spreading. In 1997, Peter Maass noted in the book *Love Thy Neighbor: The Story of War:*

At the end of 1994, when everyone involved in the Balkan crisis knew that Bosnia was being left to twist in the wind, an unusual death notice appeared in The New York Times. Bordered in traditional black and signed by more than seventy members of the Western world's political and cultural elite, it stated the following:

IN MEMORIAM
Our Commitments,
Principles, and Moral Values

Died: Bosnia, 1994
On the occasion of the 1,000 days
Of the siege of Sarajevo [15]

My mom and dad, November 1994:
We have received your letter number six from the new series and, of course, found out the most wonderful news about the baby! It instantly turned this gloomy, cold, gray day in Sarajevo into paradise! We can't tell you how excited we are to be grandparents and thrilled that you and Djeno will soon experience

the feeling of being parents. There is nothing that compares to it—yes, your life is not exactly yours any longer, but when it extends into the lives of your children, it becomes richer. Your children's achievements, failures, and everything else in between are yours as well, and when you are old, like the two of us now, you almost have no wishes for yourself—the whole meaning of your existence comes down to your children's happiness. It may sound strange, as if you are giving up on your own life, but somehow your whole being transforms into your children's shadow—when they are sad, you are, even if everything is going perfectly well for you. When they are happy, you are as well, even if you are in hell—we can attest to this.

You said you are scared and worried for your baby's future. We under-stand. But think about this, Sanyushka: You and Djeno have already done so much for your future there—even better opportunities will come with time. You will be wonderful parents; we know that. You are ready. And your child will already have a much better start than so many others born elsewhere in the world, let alone here. That is already a big gift you have provided.

We were talking today about the day you were born, our little baby girl, almost exactly twenty-nine years ago to this day, on a freezing winter night in Moscow. It was the Day of the Republic in Yugoslavia[16] and the embassy staff was at the reception party when you came into the world. Alija came to the hospital and brought Zoran with him, all bundled up in his winter gear, his cheeks red and his eyes wide open, curious. I felt like I was in heaven. Our family was now complete.

In these twenty-nine years, a lot has happened. You went from being a Russian-born Yugoslav to Bosnian, and now almost American. Who would have thought, right? Look at us—once we were well-situated, respected professionals in this city, a couple with good prospects for a comfortable retirement. Now, we rely on bread from humanitarian relief and should feel privileged to get half a pound of stale cookies as well—a treat for senior citizens. What we want to say at this time is this: Do not think or look too far ahead. We know you are not the kind of person that lives for today only, but you can't plan your life, let alone your child's. There will be people, events, and circumstances that will shape it without your control. You know that by now. So, try to enjoy every day the best you can.

In the spring and summer of 1995, the situation in Sarajevo progressively worsened. For the first time since 1993, schools were closed due to increased shelling and sniping, and most supply roads leading into the city were blocked.

May 24: The U.N. reported 2,758 detonations in the city.

June 18: Seven Sarajevans were killed and twelve wounded while waiting for water in a Sarajevo suburb.

June 21: Six killed and fifteen wounded.

June 25: Two children killed, eight wounded.

July 1: Twelve killed and sixty-seven wounded in simultaneous shelling of all city neighborhoods.

July 12: Six killed, twelve wounded.

August 10: Four killed by snipers.

August 22: Six killed and thirty-three wounded.

August 28: Thirty-five killed and ninety wounded in a renewed Markale market attack.[17]

But then, in my mom's words, "somebody important somehow figured" there had been enough bloodshed in Bosnia. At last, after three and a half years, the world intervened. In the early-morning hours of August 30, NATO's war planes roared over Sarajevo. Soon, bright flashes illuminated the dark sky as the first wave of airstrikes began, carried out by aircraft from military bases in Italy and a U.S. aircraft carrier in the Adriatic Sea.[18] President Bill Clinton called the intervention "an appropriate response to the shelling of Sarajevo. I believe it is something that had to be done. I strongly support the operation."

It was swift and precise. In less than three weeks, it brought to an end the longest siege of any city in modern history. After 1,425 days and an average of 320 bombs per day, Sarajevo, or what was left of it, was free.

The daily count of casualties in the city that began in April 1992 stopped at 11,541. This translates to a monthly average of 260 Sarajevans killed for the

duration of the siege. Of this number, thirty-four were children. In other words, *one child was killed every day in Sarajevo for forty-four months.*

The aftermath of the urbicide was astounding. Ninety percent of city buildings were destroyed or damaged in some way, making whole neighborhoods virtually unrecognizable. Sixty percent of housing was uninhabitable. Olympic Games sites and facilities were obliterated. Infrastructure effectively did not exist: No road, tunnel, bridge, railway, power plant or factory was left intact. The Architects' Association of Sarajevo was preparing for what was called a "Post-Warchitecture" symposium in Germany in hopes to rebuild the city with at least some of its pre-war architectural beauty.

The historical, religious, and artistic heritage of the whole country suffered such enormous destruction that the Council of Europe called it "a cultural catastrophe":

"Historic architecture, works of art, as well as cultural institutions have been systematically targeted and destroyed. The losses include not only the works of art, but also crucial documentation that might aid in their reconstruction. Throughout Bosnia, libraries, archives, and museums have been targeted for destruction, in an attempt to eliminate material evidence that could remind future generations that people of different ethnic and religious traditions once shared a common heritage in Bosnia. While the destruction of communities' institutions and records is, in the first instance, part of a strategy of intimidation at driving out members of the targeted group, it also serves a long-term goal."[19]

In Sarajevo alone, 1.25 million books, including over 155,000 rare books and manuscripts, along with the whole University of Sarajevo collection, were burned in the attack on the National Library. The Manuscript Collection of the Oriental Institute, which was considered one of the richest collections of Islamic and Jewish manuscripts in the world, as well as 7,000 Ottoman documents covering five centuries of Bosnia's history, were lost. The National Museum lost much of its collection in the attack that took out more than 300 of the museum's windows. Its director was killed later while trying to cover them with the U.N. plastic sheeting.

Guardian Weekly, October 29, 1995:
According to the official statistics, Sarajevo had 1,991 highly skilled technical professionals before the war; today it has 733. The Academy of Arts and Sciences of Bosnia had forty-eight members before the war; today just sixteen. Almost 2,000

people were on the faculty of the University of Sarajevo when fighting broke out;
now there are half that many.

Twenty-five thousand Sarajevans left the city in the past three months in
the biggest exodus from here since the war began, according to High Court statistics
published last week. There is a massive shift in the ethnic and cultural mosaic of this
city that, while it started in 1992, has accelerated recently as more and more intel-
lectuals and skilled people have come to the conclusion that their city and country
have changed beyond repair. And people who are leaving could form the foundation
for a democratic state.

My dad, December 1995:

You might wonder what it feels like to live a somewhat normal life
again—to go out without fear of bombs and snipers, to walk down the street and
stop to greet a friend, to sit in a cafe. You surely think it must be a thrilling experi-
ence—and it is, but somehow, we are not overcome with joy. You won't see people
celebrating freedom in the streets and crowds congregated at city squares. We are
exhausted, weary, and, I must say, skeptical—but you cannot blame us. It will take
Sarajevo a long time to heal, for it has never been scarred worse in the 600 years of
its existence.

This war has been nothing like any other war in this part of the world
before. The dirtiest, the ugliest, the cruelest of them all. Just like the war, the peace
will be nothing like any peace achieved in the prior wars. This war ended with no
clear winner, without the thrill of liberation, without the joy of defeating the aggres-
sor. I can only hope that one day the aggressors will pay a big price for what they
have done to this city and country, to its innocent citizens and children. I hope they
will be condemned by the whole world for generations to come. That's what I wish
for them, and that is the only thing that is fair.

Many people here believe this peace can hold. I am trying to be optimistic,
too. I hope the road to recovery and reconstruction is now open for us, if we manage
to organize ourselves and use international help wisely. Many organizations have
opened offices in the city, including the Office of High Representative and the World
Bank. Bosnia is now a member of the International Monetary Fund, and we hope
to receive the first tranche of their long-term loan soon. Germany has already
donated money for repair of the city's water system, so we hope the situation with
water will soon drastically improve. As far as heating, it is still bad. I have repaired

our old gas stove. We still have a lot of wood pieces of the weekend house, which we brought here in the fall.

The other night, for the first time in four years, I took a walk through the old town when it was dark. I thought I would enjoy it. It was snowing and it looked very peaceful. I didn't have to run or take side streets. I went down the carsija main street, since it was the only one lit. There were hardly any people out. It felt very alienated, very strange and obscure. I walked all the way to the square, which was completely empty and dark. Even in darkness, I could see shadows of destruction around. I paused there for a moment. I remembered a night in February 1984, when Dzaja and I stood here, on the eve of the Olympics. It was crowded, lively, buzzing with life. Each little shop and house was illuminated; restaurants were open at midnight; the tourists were captivated by the beauty and charm of this place and the hospitality of our people. The whole city was one happy soul with one big, warm heart.

I walked back home, sad and disappointed, feeling nothing but cold emptiness inside. I don't know what I had expected—I should have known better. But somehow, that night I became scared that the carsija will never be the same as before and that Sarajevo will never recover. Houses will be rebuilt and trees will grow again, but that is not what the soul of this city was. I can only hope that the spirit of Sarajevo, which carried us through these past years, will not vanish now.

Don't get me wrong, though. The most important thing is that the bombs are not falling and that we are not prisoners in our own homes anymore. We are alive and in one piece; that is all that matters. It will get better from now on.

Now I want to wish you a Happy New 1996! May you be healthy and happy with your little princess, and may we live through the next, and many more years, in peace.

I hoped with all my heart that my dad was right and that the spirit of Sarajevo would not die. How could it? That spirit rose above the agony of this brutal war and bonded people in their fear and struggle to survive. It was the spirit of resilience and ingenuity that created *life* under the siege: more than 100 art exhibitions, 250 concerts, forty new theatre productions, plus children's plays, poetry evenings, and war cinemas. It created humor from humiliation, restored faith in humanity and dignity amidst deep moral degradation, and built meaning of existence from utmost hopelessness. Without it, I was certain, the city would have died, slowly bleeding to its end like a wounded warrior left on the

battlefield. I thought, *How could it die now?*

Now that the siege had ended, the vision of Sarajevo I had in my mind, however physically destroyed, was still in some ways the same as before. I knew it was not the city I left—I have heard that phrase many times. I knew many of my friends would not be there any longer. But I refused to think I would not belong there. It was still my home, my beloved Sarajevo. I thought, *One day, when I return, I will stroll down the main street just like I did in peaceful times, sit in a cafe in front of my school sipping espresso, have cevapi at Zeljo's and ice cream at Egypt's.*[20] *I will walk through the old town when the first snow comes. Stop by the bakery to buy hot kifle*[21] *on the way home. See a few familiar faces along the way.* And I thought I would still feel the same easygoing vibe of this unique city, the same calming-but-effervescent rhythm of life that has existed there for hundreds of years. Its heartbeat would still be effortlessly weaving through each sphere of life and through the soul of every Sarajevan.

Despite all that happened, I could still not think of Sarajevo being anything different.

PART IV
1996

Have you heard of a company named Parsons?" my dad asked during one of our phone conversations.

"Yes, Dad, of course," I said. "It is a big engineering firm here in Pasadena. Their CEO was killed when the Air Force plane that was carrying Ron Brown crashed near Dubrovnik."

"I know," said my dad. "It was all over the news. They were here to explore possibilities for American companies to participate in the rebuilding efforts. One of my friends, a CEO of a local engineering company, told me other Parsons executives visited here on another occasion. He met with them last week. Do you think you might want to contact them, since you're looking for a new job? Maybe it wouldn't be a bad idea. I can give you the names of the two gentlemen who were here."

Well, this was strange: My dad was helping me find a new job in Pasadena from Sarajevo. I was not sure what to think of it, so instead I wrote down the names and told my dad I would think about it.

"You've got nothing to lose," he insisted. "Perhaps you'd be an interesting choice for them. You have education and work experience from both countries. You'd be a good asset. If I were them, I'd hire you."

"Of course you would, Dad!" I said, laughing. "All right, I'll call. I am now curious more than anything else. It doesn't hurt to try."

So, I called and left a message.

Several people were already in the room when I arrived for my interview. All were involved in the proposal for the U.S. government contract in Bosnia. Among them was my dad's contact, one of Parsons' business development managers. He spoke to me first.

"How did you hear about us? It's not every day that I get messages like yours."

"Well, I am originally from Bosnia and my family still lives there. My father told me you were in Sarajevo and that Parsons might be participating in an infrastructure-rehabilitation project there," I said slowly. "His friend is one of the local executives you met there."

"I see. Yes, we are in the process. But we don't know yet if we will be awarded the job. If we do, Parsons will be the prime contractor and we will partner with a local construction company. There will be a few other American companies in the consortium as well—engineering, architectural, and demining."

The conversation then turned to the current situation in Bosnia. I was grateful my dad had given me a thorough report on the state of the economy and the banking system, monetary, and fiscal problems the country was facing, especially given its extremely complex political situation. Several times throughout the interview, I thought of Djeno and his words of encouragement and support. I knew Parsons had big finance and accounting departments and did not hope for much from this interview, other than to present myself well. Nothing could prepare me for what I heard next:

"Sanja, would you consider going to Bosnia to work for us there?" asked one of the managers when I returned to the room from a short break.

I was sure I had not heard this correctly.

"I am sorry; could you repeat that? I am not certain I understand you correctly. Did you say to work *there*?"

The room was already blurry.

"Yes. If we win the contract—and we will know soon—we would like you to be part of our finance team in Sarajevo. Initially, it would be a small group of people, to set up the office and take care of the logistics. Then, more people would come from here. It would be a two-year contract."

My heart started pounding so hard I thought everybody in the room heard it. I felt my face turning red and my makeup melting; I was scared I was going to faint. I closed my eyes but could not tell if I meant to do it or if I actually blacked out for a second. I looked up and saw the same faces from a few moments ago, still smiling, waiting for me to say something. They could not have known what this meant to me, how inconceivable, how utterly unimaginable, it was. They did not know what we had been through in the last four years. They did not know our story. They were asking me if I wanted to go back home, to work there on rebuilding my hometown, and while doing so, earn an American salary. How wild, how out of this world, was all this?

Tears flooded my face and I could hardly control my voice. I vaguely remember visiting other offices and meeting more people, but ever since that question had been asked, I was absent, drifting aloft from the current place and time. In my mind, I was already traveling to Sarajevo.

At home, Djeno and I stared at each other in disbelief, me repeating what had happened at the interview and wondering how it was possible to be struck with such huge luck, and him asking more questions. It was altogether so surreal, so daring, that we did not gather enough courage to tell anybody. We kept my new job a secret for almost a month, until we were completely sure everything was clear for me to go. I did not have either a valid American or Bosnian passport. I would travel with a green card and a document called a "white passport," which is a permit to re-enter the United States. A million other formalities had to be sorted out as well.

When all was set, we called my parents:

"Dad, I have to thank you—you got me a job!"

He, of course, did not understand. He had forgotten about Parsons a long time ago. He was busy repairing and painting the house. When I told him Parsons had not only hired me but was sending me to Bosnia, I first heard the clanking noises of his tools falling to the floor and then his shouts:

"Dzaja, Dzaja, come here, quick!"

"What? What happened?" I heard my mom's worried voice in the background.

"Sanja is coming! She is coming home!" His voice was shaking. "We will see our grandbaby, Dzaja!"

It was a struggle to understand for all of us—for them to accept the information and for me to realize the truth of it, now that I had finally said it out loud. We were all talking at the same time, laughing, crying, screaming. It was all too good!

Mrs. Hughes cried when I came to say goodbye. She hugged me, then took my hands into hers and said she knew from the beginning that something good was in store for us. Then she gave me a lecture on how shocked I would be when I got there, how I should prepare myself for some difficult times and maybe even some depression. She knew Djeno would bring Nadia to Sarajevo once I settled down, and they would join us later, once he finished his degree, but she was worried how safe it was to live there, especially with a ten-month-old baby. I was looking at her nodding my head, but I was not listening. In my mind, there was no room for anything but joy. I was not scared or worried, not concerned about safety or my new job. Everything was overshadowed by the greatest feeling of all: *I was going to Sarajevo.* My suitcases, the same ones we brought here on our honeymoon and hadn't used since, were packed.

Sarajevo's airport was under UNPROFOR's control and closed to civilian traffic, so after I landed in Split, Croatia, I had to continue by car. My driver, Adem, said the trip to Sarajevo, normally a six-hour drive, would take us almost twice as long. We had to take detours due to damaged or destroyed viaducts, tunnels, and bridges. Various UNPROFOR checkpoints were along the way and at a newly established border between Croatia and Bosnia where, Adem said, the wait was usually very long. I did not mind. I felt happy and excited, on my way home. Everything around me was familiar, although we had yet to enter Bosnia and I was technically still "abroad." But only a few years ago both Bosnia and Croatia were Yugoslav Republics and I could not help but already feel at home in some way. The beautiful Croatian coastline was everyone's favorite vacation destination and I had spent many unforgettable summers here. We, the Yugoslavs, loved "our sea," the Adriatic, and were convinced it was the most beautiful one in the world. We, the Bosnians, spoke the same language as the people here. I could not quite come to terms with the fact that this land was a foreign country for me now.

A few hours passed before we reached the border. Situated on a two-lane highway, in the middle of nowhere really, it looked like anything but an official international crossing. Simple booths were set up on either side of the road. On one side, a new Croatian flag, and on the other, the Bosnian flag. The officers were unfriendly and suspicious of my "white passport." I had not considered that I would have to explain myself or my intentions for coming back, nor did I think I would have a problem bringing a company computer with me. After lengthy questioning and much guarded whispering amongst the officers, I was allowed to enter the country. As for the computer, a special form had to be filled out, and I would have to show it again on the way out of Bosnia. The form was not attached to my "passport," so I could not understand what all the fuss was about—I could have easily thrown it away. Adem lit a cigarette, laughed, and said not to think too much of it—I would come across plenty more instances where things would not make sense in Bosnia these days. All that mattered was that we crossed the border.

The route heading north from the Croatian coast toward Sarajevo was once one of the most beautiful scenic drives I had seen anywhere. It follows the

Neretva River upstream, through a magnificent narrow canyon with almost vertical walls of layered rock, to a lake that perfectly reflects its surroundings in calm, green water as if it were a mirror. Further up the road, the air becomes crisper and the scenery shifts: lush hillsides decorated with haystacks and herds of sheep, villages nestled in the background, local restaurants along roadsides, and vendors selling honey and wild strawberries to travelers. Now, it looked and felt so different that I did not even notice its natural beauty. I was quickly losing interest in chatting with Adem and becoming painfully aware of how poorly I had prepared myself for this return. How could that be and where did I err? I knew well the whole country was in ruins. I had been watching it on the news daily, reading about it endlessly. But I had not realized until now that it was one thing to read about the wrecked towns and burned villages of Bosnia while sipping cappuccino on the Promenade in Santa Monica. It was entirely different to be here and to see them with my own eyes as I passed through their empty streets and felt their eerie stillness with every ounce of my body.

Traffic was heavy due to the army convoys, an endless procession of trucks, armored vehicles, and humvees trundling across pontoon bridges and lifting up clouds of dust as they slowly moved on dirt detour roads. Civilian traffic was rare. Checkpoints were everywhere. As promised, the trip took more than ten hours. When at last we came to the outskirts of Sarajevo, I asked Adem to make one more detour. We were passing by the place where my parents' weekend house had been. I could see part of my parents' land from the road we were on. He asked me if I was sure I wanted to see it now, and I confirmed. He had good reason to ask.

To get to the house, we had to drive up the hill from the main road and pass through a community of about a hundred households. I used to know every soul who lived here and I hoped to see some familiar faces. During the summer months, they used to spend most of their time outside—men working in the fields, their machinery loudly whirling, folk tunes blasting from radios in the background, kids playing soccer, and women chatting and drinking coffee sitting on their doorsteps. But as we approached the first cluster of homes, it seemed no one lived here anymore. Shells had blown huge holes in thick concrete and brick walls. Many homes were missing more than half of their structures, and blown roofs were now covered with plastic sheeting, "secured" by a couple of stacked bricks in each corner. The destruction was so systematic, as if someone purposely

decided not to spare even one house. When we drove closer, I could see people still lived in the houses. But there was no sound of life outside and no one stood by the road to see us drive by. In some parts of the village, more exposed to the hills on the opposite side of the main road, houses were leveled to the ground, and had I not known for sure that they once stood there, I would have never guessed. Here, the road was so badly damaged that we had to park and continue by foot.

One more turn and we were there. I remembered what my brother once said about the house, knowing its location at the top of the hill—that it was only a matter of time before it would be directly hit. As we approached, there was a crater in the ground every few yards. On the side of the road, where my dad had built a fence, each piece of the wooden structure, including strong supporting pillars, was ripped out, completely dug out from the ground. All that was left were metal parts and wiring. When I saw the gate, I stepped off the asphalt road and started running.

"Stop right there, Sanja! Don't move!" Adem yelled behind me. "Stay on the road. There may be mines there!"

I turned to him in disbelief and shock.

"Mines? Here, on this property? In this village?"

"Yes, they could be anywhere," he was out of breath as he caught up with me. "Sanja, you have no idea what took place here. You are in Bosnia now, remember that."

My heart sank. Unable to move, my legs still shaking, I held onto the gate and stared at the ruins of my parents' fairytale house and garden, years of their lives. The landscape was so different I could barely recognize it. The thirty-five fruit trees my dad was so proud of—he had planted them himself, watched them blossom, and given me the first fruits he picked from them—were nothing but stumps hardly visible amongst the growing grass. The silver pine, my mom's favorite tree, once decorating the large front patio, was cut in half. Only one oak was still there, too huge to be cut down for wood. But it, too, was hit by a bomb, and several of its thick branches were hanging lifelessly.

Adem took my hand and helped me walk farther up the hill, carefully guiding my every step over stones, bricks, and concrete blocks, until we reached the stairs that led to what was once the entrance to the house. We stood on the rubble, in the middle of where the living room used to be, now an open space with only part of one wall remaining. The chimney and the fireplace were still

standing, and the little antique ornaments my mom had placed there were still visible, perfectly lined up.

I turned around to see if I could find anything to take home with me. I scanned the ground, searching for something other than debris and rubble, a memento, a proof of our life as it once was. There was nothing. I looked to the side, at my Mom's rose garden. Most of it was overgrown by weeds, but two of her roses, a red and a white, were still flowering. I wanted to pick them up but was too scared to step farther. I stood there a little longer, scenes from the past uncontrollably rolling in front of my eyes. *What would have happened to Djeno and me had we stayed here and made this house our home?* I asked myself again, as I had many times before. *Would we have managed to leave in time? Or...?* This time, however, the thought of it shook the very core of my body. Suddenly, my legs became weak and I felt a strong urge to leave. I could not stay there for another second. My head was spinning and I was nauseated. I went back to the car, scared of my own reactions. I wished I had not come here at all.

In front of me lay Sarajevo. Its wounds, the aftermath of hundreds of thousands of bombs, were visible in every direction. I could not spot one intact structure for miles around. Zetra, the Olympic Hall, built less than two decades ago, was burned down entirely, with only its metal skeleton structure remaining. Next to it stood the damaged tower with three of five Olympic rings missing. In front of it, a speedskating stadium, now a depot of metal junk and garbage. Farther down, a soccer field completely covered in endless rows of simple white tombstones. Only twelve years ago, the athletes of the world had marched here and celebrated the unity and peace that sport brings to the world. How unimaginable, how awful these thoughts were now. In the distance, high-rise apartment buildings were mostly windowless and cratered all over, many of them blackened from fires. Cemeteries were everywhere, small or big, depending on the area. Those by the roads and farther up from the city center were larger, while smaller ones occupied areas around residential buildings and parks. As far as my eyes could see, there was nothing reminiscent of the modern city, full of vigor, I'd left only four years ago. I could not even hear its busy buzz, horns honking and trolley buses whirling, sounds of life echoing from the valley below. Its silence made me cringe. It was as if the city had died.

As we approached my parents' home, I forgot I had not slept in thirty hours. I ran up four floors of our building in an instant, dropping my luggage along the way. I looked up and there they were: my Mama and Tata, my two heroes, survivors, my two icons. They stood at the top of the stairway in front of our home, waiting. The next few seconds—the look on my mom's face, her arms extended toward me, her soft brown eyes immediately filling with tears, her almost silent whisper, "My dear child…"; my dad's exhilarated expression, his arms around me, his body trembling—filled my heart with such everlasting happiness that I cannot think of them as seconds. In my mind, they became eternal—neverending sources of contentment, satisfaction, and joy. I'd finally come home.

We went inside. My small room in the back corner still had the same posters on the walls, white curtains on the window, and my piano. I walked through the house accompanied by my parents' stories about what had happened when and where—the shrapnel stuck in the wall above their bed, plastic sheeting on the windows recently replaced with glass, water that would come on in a few hours, the makeshift stove finally removed from the living room and a freshly painted wall behind it. I walked everywhere touching things softly, feeling the warmth like every person does upon returning home from a long journey. Everything was in its place and looked the same as when I left. Yet, it was oddly different, as if centuries had gone by. I felt like I'd lived two distinctly separate lives, one a long time ago, faded and almost forgotten, and the other one just beginning. The four years in between seemed like limbo, a vague existence, in which the old life died and the new one emerged. At this moment, it felt as if someone else had lived them.

We sat at the dining room table, and only then did I look at my mom and dad more closely. My dear parents…They smiled, but the misery they went through showed on their fatigued faces with deep wrinkles around their eyes and on their foreheads. They looked decades older. My mom's hair was completely white, like snow. My dad had lost a lot of weight and looked tired and frail like never before. His eyes were weary, their blue color somehow darker than usual.

I took my mom's hand in mine and stroked it several times. Her hands used to be so well taken care of, her nails always perfectly done. Now they were covered with scars and burns. Her skin was rough and her knuckles ruptured in a few places. Her nails were chipped and fragile. I looked at her, but she only shrugged her shoulders and said it could have been a lot worse. I told her I did not care. Those were still my mom's hands, the most beautiful hands in the world—hands that held mine whenever I needed support, hands that rested on my cheeks and stroked my hair whenever I was sad, hands that knitted blouses for me in the darkness of the war. I kissed them and held them in mine until I fell asleep. It felt serene and calm.

Water did not come, so the next morning I "showered" with a two-liter canister of water. The gas was on, so I heated the water.

"I am so sorry, Sanyushka. The water was supposed to come last night—we usually have it in the morning and at night," said my mom.

"Not your fault, Mama! Look on the positive side—I am getting a bit of your experience from the war."

"Don't ever say that," she replied, her face suddenly completely serious. "God forbid you ever experience anything close to it."

She walked away and added that what I said was not even true—compared to the siege, I was now living in a five-star resort.

During the next few weeks, I was still naively searching for my old Sarajevo. I refused to accept that it was lost, even after the euphoria of my return had passed. I hung on to this for a long time, looking for things that would prove it was still there, going to places I loved, searching for friends who remained, wanting to continue where I left off. Sometimes I thought it worked, as glimpses of my old life made their way through and the years in between did not seem to matter. But over time, these instances became more uncommon, as my memories from the past remained just that: memories from childhood and youth. What now connected the people in Sarajevo was something I did not have—life during the war—and I began to feel strangely unattached.

Too many stories began with "In the war…" and ended with "You were not here in the war." Too many of my questions were answered with "You will never understand." And I could not offer anything in return. I felt ashamed to talk about or even mention anything from my "survival" story in America, because as it turned out, I was living a dream life. Things I worried about, lost sleep over, and cried my heart out for were petty, insignificant details compared to what people here had to overcome: learning to live without limbs, collecting money for prosthetics and surgeries abroad, helping an orphan child understand her situation, or raising a child born to a rape victim. These, and countless others, were not isolated incidents that happened here and there. For the people of Sarajevo, these were widespread, everyday issues. This siege, I realized, had left physical and mental scars so deep they would take generations to heal. And for me and all others who were not here, it would take a lifetime to grasp their magnitude.

Still, Sarajevans are a strange kind. Proud, strong, enduring, and kind. I watched them walk around town, going about their lives as if everything was all right—as if they'd never lived through hell and were not reminded of it every day. They had a new appreciation for life, one I had seen only in people who had survived awful illnesses and were given a second chance. The war had taught them a new set of values; "little" and "normal" things many of us take for granted meant

a lot more than an expensive car or a new house. They cherished the ability to go out, buy a book or a piece of clothing, leave the city for a weekend, go on a hike, see a movie, turn on the lights or water, or eat good food.

"Before this war," my mom told me, "I truly thought my life was hard. All the stress from everyday life, problems that looked big, all these obstacles in front of me…I never realized that overcoming these 'problems' was the charm and beauty of my life. I thought my life was extremely complicated, where it was, in fact, rich and full. From this perspective, the 'tough' times I had were just a joke."

Every day, my mom taught me how to cook "in case of need" and how to make the most out of every ingredient. Like Zoran, she would not let me throw anything away, from bread crumbs to sandwich bags—she collected the crumbs for breading and rinsed and reused the bags. It was incredible how little garbage we would accumulate. My dad showed me how to make "candles" from oil and shoelace and proudly demonstrated his rainwater collection system from the roof of the building. It was good to know, he said. Every day upon returning from his walk, he would marvel at how awesome it was to go out, enjoy the summer weather, have coffee with his friends, then buy a paper and a fresh loaf of bread on the way home. A friend of mine, who'd lost a leg in the war, climbed five flights of stairs to visit me. He even made a joke about it when he realized how bad I felt for not visiting him sooner. And after several weeks of being here, I could not help but agree with those people who told me, "You cannot understand us; you were not here." I could not understand them, but I could admire them. And I did, enormously.

I took long walks by myself, examining the streets, bridges, and buildings, staring at craters in asphalt and walls, and quivering at the thought of the kinds of force that created such destruction. Most of the downtown area was still in ruins, but some shops and restaurants were restored and open. I went to the carsija several times to eat cevapi, but each time, my favorite restaurant was full of U.N. soldiers and other foreigners, and I always felt a need to leave as soon as I ate. At the square, pigeons congregated just the same as before and I could hear the familiar sound of coppersmith tools coming from tiny souvenir shops. Along with traditional handcrafted coffee pots, cups, and trays, they were now selling vases made of bullet and bomb casings, varying in sizes from several inches to a foot or so. They were beautifully engraved with motifs of Sarajevo.

The bakery where the breadline massacre took place in 1992 was open. In front of it, for the first time, I saw a "Sarajevo rose." A huge bomb crater in the street, a hole about two feet in diameter, and dozens of smaller ones around it were filled with bright red asphalt, resembling a rose with many of its petals fallen and scattered around. As I stepped on it, chills went down my spine in an instant. I paused for a moment. I thought of Djeno's professor who lost both legs that morning standing in line for bread. I envisioned Mr. Smajlovic playing his cello in this crater, and the silence in the street interrupted by his music and snipers whizzing through air. I opened my eyes and looked around. Life went on, people were walking by, and many were gathered in the bakery, chatting. The pleasant smell of fresh pastries and bread filled my nostrils. I went in and bought several *kifle*. When I got home and told my parents about the "rose," my mom said: "See, it is not just Pasadena that is called City of Roses. Sarajevo is, too."

24

As time went by, it became increasingly difficult for me to reconcile where I belonged. People would often ask me if I was an American, how I ended up on the Parsons team, and where I lived. I was never quite sure what to answer. Nadia was now with me and Djeno was planning on joining us soon. My parents were there, and we lived with them. We were back in Sarajevo, where I so badly had wanted to come for years. I sure did not feel like an American there, but I felt like I did not belong in Sarajevo anymore either. I was there on assignment and would eventually go back, just like my American colleagues. I went on R&Rs and "home" leaves to the States and carried around a badge that stated I was under aegis of the U.S. Government. When we had to pay our local subcontractors in cash, I traveled around the country with a U.S. Army military escort. All this hardly qualified me as a Bosnian.

Why was it so hard? Why couldn't I be at peace with myself? By coming back to Sarajevo, I thought I would close the circle, gain some sort of closure, figure out where I was and where I wanted to be. But it was all a futile effort and I was more confused than ever. I did not want to leave Sarajevo again, perhaps because I knew that this time around, the decision would be final. At the same time, I did not want to stay there. I wanted to build upon the life Djeno and I had created for ourselves in America.

What I could not grasp then was that I would always, for the rest of my life, be balancing memories and reality and living somewhere between Pasadena and Sarajevo. It was impossible to pick one and forget the other, because both were a part of me now. The life Djeno and I had in America, however unique and our own, would always be valued against the life we once lived in Bosnia; we would never quite fit here or there—we would always be Americans in Bosnia, but Bosnians in America. We would always be measuring and comparing, doubting, and questioning ourselves and the decisions we made. Once taken away from our roots, we would forever be searching for the proof that we fully belonged somewhere. We will never find it, because, for people like us, such a place does not exist.

Epilogue

On Christmas Eve 2005, Zoran and I went to Sarajevo together with one goal in mind—to make it in time to see our dad one last time and say our good-byes. His cancer had spread, and he had only days to live. When we arrived at the hospital, he was already in a light coma.

"Tata, Tata," I whispered through tears. "It's us; we're here."

He did not move. His eyes were closed, his face still as a stone. "Alija, wake up," one of the nurses said louder, gently shaking his shoulder. "Your children came." Then she turned to us: "You know, all he'd been saying in the last few days were your names. We all learned them."

Nothing happened, not even a twitch on his face.

I took his fragile hand into mine. Zoran sat on the other side of his bed, and with that, the waiting began. Hours passed in silence, occasionally inter-rupted by monitors beeping and nurses walking by. But then, right before dawn, my dad opened his eyes. He looked around with a somewhat lost gaze, but when his eyes met mine, he smiled. He squeezed my hand lightly.

"Everything is great," he said slowly. These were his last words. Then, he closed his eyes again and his hand relaxed.

I want to believe that, from that moment on, he was content. I want to believe he was not in any pain, that his last few days on this earth were filled with dreams of happy times from his life, of the times we spent with him, joys we brought him, ski trips we took, laughs we shared. I want to believe I was a good daughter and he could say he was a proud father.

We kept taking turns at sitting by his side in the hospital and staying at home with Mom. A few days later, on a snowy New Year's Eve, Dad left us.

"It is hard for me to stand here and speak," my dad's best friend said at the funeral. "Alija and I have been friends for more than sixty years—in good and bad times—through wars, poverty, difficult personal struggles, great challenges of our public careers. Six decades is a long time to keep a friendship alive—and we managed to do just that, and more, by always supporting each other uncondi-tionally and growing our friendship stronger as years and decades went by.

"When we were young, we dreamed of the people we wanted to become

as adults. We formed families and brought them close. We wished each other nothing but the best, feeding off each other's successes and accomplishments. If one of us was worried, we worried together. We considered each other's problems our own. The tougher they were, the stronger we stood by each other's side, like brothers.

"I have no words to express what our friendship has meant to me—just as I have no words to describe how I feel now that Alija's death has brought it to the end. Yes, thoughts and memories will stay, our families will remain close. I will cherish the wisdom we learned together. But that is hardly a consolation for me.

"My dear friend, I cannot wish you anything any longer. I say goodbye to you with the deepest pain in my heart. That is all I can say. In my name, and in the name of many of your friends, I thank you for everything you have given us. May you rest in peace, in your beloved Sarajevo."

We left Mom all alone in their big, empty house. She herself was ill, recovering from colon cancer. Saying goodbye to her and going back to America that year was one of hardest things I ever did as a daughter, even harder than placing roses on my dad's coffin and listening to chunks of frozen dirt fall onto it.

* * *

Many years have passed. Our children, Nadia and Leila, are young adults now. They grew up a few miles from Margaret's house on Rose Villa Street, where Djeno and I first arrived on our honeymoon. Nadia is attending graduate school, working, and has moved away from home. Leila is in college. I have been working for Parsons for twenty-two years and Djeno has been with the same company since we returned from Bosnia in 1998.

We have been going to Bosnia every year since then. For many of those years, the phrase "I am going home" was applicable in whichever direction I traveled. It meant just that—I felt I still somehow had a home in both places. I would be excited for months ahead of each trip to Bosnia but also happy to come back to my home and my life here. Sometimes, I was nostalgic for Sarajevo—when my family would get together and I would be the only one missing, when the first snow would fall, when the city would burst with life in summer months. The strength of these feelings used to startle me, as I had thought I was not vulnerable

131

to them any longer. In these strange moments, I felt the only place I could truly be happy was Sarajevo. But over the years, this nostalgia faded in intensity and frequency until it finally quieted down. I do not know when or how, but something changed, and I was no longer going home both ways—I started going to Sarajevo to visit family and going home to California.

Zoran and his wife, whom he met and fell in love with on one of his trips to Sarajevo, lived in Pasadena for ten years. But when their twins, born only a month after our dad's passing, were two, they decided to move back to Sarajevo. Today, their daughter attends the same music school I did and practices on my old piano. Their son plays tennis on the courts Zoran helped build when he was a student, and he is already a member of the same soccer fan club Zoran has been a member of his whole life.

Amila and her family still live in Pasadena. The boys, Adi and Dino, have long forgotten their childhood refugee years in Croatia. Both have graduated from college and are making their own lives in the United States. Amila has dedicated her whole career to helping refugees travel to and settle in the United States.

Through the years, we have made new Bosnian friends in the U.S. Their life stories are similar to or, in many cases, more complicated than ours—some came as refugees, others as medical evacuees, barely making it out of Sarajevo alive. But we all have something in common that links us for life. We are all that unique breed: Sarajevans. Regardless of our degrees, professions, or ethnic or religious backgrounds, we are so very similar—we share the same mentality, the same humor, and we recognize in others our own principles, values, and attitude toward life—all deeply rooted in us a long time ago. We discovered some of us had somehow met before or went to the same school, liked the same bands and same clubs, or our parents worked together, or someone knew someone else's relatives. Thus, we made our little Sarajevo far away from the Balkans, in Los Angeles. Because of it, we will never be "real Americans," regardless of how well we assimilated into the society. We have all made good livings in the U.S. and speak English well. We all have professional and personal accomplishments. Yet our children will forever make fun of our accents and wonder why we, in more than twenty-five years of living here, never went to a football or a baseball game. We will never quite grasp distance in fractions of miles or hear the difference in pronunciation of "man" and "men," except that one has a longer "e" than the other. We will never get used to drinking coffee from a plastic cup in a car and

will never admit that two slices of bread from a plastic bag with anything in between, let alone peanut butter and jelly, makes a good sandwich. We will strive, for the rest of our lives, to retain that little bit of Sarajevo in us in whatever we do and will teach our children the same. We want them to keep it in their hearts forever, wherever life takes them.

I love that fact that Nadia and Leila do not know the ethnic backgrounds of their Bosnian friends, just like we did not know any of it when we were young. I love that they speak Bosnian fluently and that they ask to go to Sarajevo every summer (even though Grandma's house does not have WiFi). They have their favorite *cevapi* place and, just like every other Sarajevan, they think there is no food in this world better than their grandma's Bosnian cooking. I love that Leila's phone case has a picture of a Bosnian flag. I love that they know every street in the *carsija* and that Nadia took her American friends there during a study-abroad trip.

I know my children will always be Americans first and perhaps rightly so—this is the country they were born in and grew up in. But I want them to know where we came from, who we are as people, what our heritage and our history are. I want them to know what happened in Bosnia and especially in Sarajevo during the siege. I do not want them to hate, but I want them to know.

I am watching my mom as she is slowly walking across the room toward the kitchen. She is taking small steps, touching the wall with one hand and using her cane with another. I am still jetlagged, but I want to stay awake and keep her company. She is making us her favorite tea and does not trust me to make it correctly.

"You just relax, Sanyushka. You are tired. Mama will make it for you. It needs to be measured just right, otherwise it's bitter."

"But you can tell me how many spoons, maybe?"

"No, no—you don't know." Her voice is gentle but still authoritative.

I know there is no point in insisting to help or arguing that, at the age of fifty-one, I am capable of following directions to make tea. I also know she wants to serve a cake she had made for me, so I decide to curl up on the couch and enjoy every moment of still being her child.

I look around the living room. The walls are decorated with several new

paintings she made after the war, before her eyesight began deteriorating. On the living room table is her little everyday world: large-print sudoku, a magnifying glass, a couple of pairs of glasses, the TV guide, and a recipe book. Next to it is a box with medications, divided by days and times of day. In the corner of the room is my grandmother's wall clock, and on the side tables, pictures of Djeno and me, Zoran and Sanela, and all the grandchildren. Everything is neat and tidy. I could tell that the rugs, curtains, and windows had been freshly cleaned—her usual routine before guests come to visit.

Soon, my mom appears carrying a big silver tray. I resist the urge to get up and take it from her, although I am afraid she might fall. She sets it up on the living room table and goes back to the kitchen to get her cane. Then she sits next to me, hugs me, and kisses my hair again, for the hundredth time since I arrived the night before. I look at her and tell her I am very happy with the way she looks and that she has not changed one bit in the last six months. We both know it is not entirely true, but overall it is. I cannot ask for more at her age of eighty-six, having survived the siege, cancer, multiple surgeries, and most recently, a stroke. She still cooks dinner every night and on Sundays invites Zoran and his family over. She likes to try new recipes even though it takes her ten minutes to read one, not only because of her poor vision but because of "mixed-up" letters after her stroke. She follows the news and sports, meets her lifelong friends for coffee weekly, even if it takes her half an hour to walk a five-minute distance to get there, and is still the most knowledgeable art history teacher her grandchildren will ever have.

"Mama, really, you are doing great," I say, and I mean it. Although she is physically weaker every time I see her, her mind is still remarkably sharp.

"I don't know what to tell you. My world is so small now."

"I know, but you still make the best of it. I wish I could be as strong as you. But I don't think you've taught me that. I am nowhere near you."

"Well, my mother did not teach me either. Life has taught me that," she replies slowly, "and I pray to God every night you get to skip some of the lessons I took."

Her hands shake slightly as she pours us tea and places a pretty plate with my favorite cake in front of me. I kiss her and take her hand into mine, immediately feeling that familiar, unique comfort. She asks me if I am cold, and before any answer, she takes her hand-knitted shawl from the chair and gently covers my shoulders with it. I tell her there is no place in the world I would

rather be now than here, in her living room in Sarajevo. I curl up further onto the couch and put my head on her lap. She tears up a little and starts stroking my hair with her soft, warm hands.

Endnotes

1. *Ezan:* Call for prayer from mosque minarets.

2. *Cevapi:* Small beef sausages served with freshly baked traditional Bosnian bread.

3. Albinoni, Tomaso. "Adagio in G Minor."

4. Titova Ulica: Main street in Sarajevo, named after President Josip Broz Tito (1892-1980).

5. Nelan, Bruce W. "More Harm Than Good: Bosnia's Brutal Tragedy Grows Worse While the U.S. and Its Allies Resolve to Remain Spectators." *Time* Magazine, March 1993.

6. Tadeusz Mazowiecki, Special Rapporteur of the Commission for Human Rights: "Ethnic cleansing is not a consequence of this war, but its goal."

7. By the end of January of 1993, the official United Nations statistics revealed the staggering number of 500 a night.

8. Pita: Bosnian dish made of phyllo dough and meat, cheese, spinach, or potato filling.

9. Beelman, Maud S. "Sarajevo Copes Despite 500-day Siege." *Times Daily,* August 19, 1993.

10. Enterocolitis: Severe diarrhea Sarajevans often experienced due to lack of clean water.

11. Letter by Mr. Francis Briquemont, written upon his departure from a U.N. post in Sarajevo. This letter was published in the local newspaper, *Oslobodjenje.*

12. Hall, Jane. "Q&A with Christiane Amanpour: On Life Near Death: In Bosnia for CNN." *Los Angeles Times,* July 14, 1993.

13. Krilic, Samir. "Bosnian Truce Delayed." *Pasadena Star News,* October 17, 1993.

14. Sarajevo Tunnel was dug secretly by volunteers underneath the airport runway and was 800 meters in length and 1.5 meters in width and height. It served as the only lifeline for city residents.

15. Maass, Peter. *Love Thy Neighbor: The Story of War.* New York: Vintage Books, 1997.

16. The Day of the Republic of Yugoslavia: national holiday in former Yugoslavia.

17. Mulic-Busatlija, S. and E. Imamovic, "Chronology of the Siege." *Our Days* Magazine, April 2002.

18. Williams, Daniel. "NATO Continues Extensive Bombing Across Bosnia." *Washington Post*, August 31, 1995.

19. Riedlmayer, Andras. "Libraries Are Not for Burning: International Librarianship and the Recovery of the Destroyed Heritage of Bosnia and Herzegovina—Abstract." 61st IFLA Conference, August 20-25, 1995.

20. Zeljo's and Egypt's: popular spots for *cevapi* and ice cream in Sarajevo.

21. *Kifle*: traditional bread (buns).

Acknowledgments

I would like to thank Paige Martini, Adi Orucevic, and Cecilia Fox for dedicating their valuable time to help me with this book.

Printed in the United States
By Bookmasters